# Closeup Shooting

Cyrill Harnischmacher

# Closeup Shooting

A Guide to Closeup, Tabletop, and Macro Photography

rockynook

Editor: Gerhard Rossbach · Translation: Christina Schulz · Copyeditors: Don Lafler, Samuel Dixon
Layout and Type: Cyrill Harnischmacher · Cover Design: Helmut Kraus, www.exclam.de
Printer: Friesens Corporation, Altona, Canada · Printed in Canada

ISBN 978-1-933952-09-3

1st Edition
(c) 2007 by Rocky Nook Inc.
26 West Mission Street Ste 3
Santa Barbara, CA 93101
www.rockynook.com

First published under the title "close-up shooting" · (c) Cyrill Harnischmacher, Germany 2006

Library of Congress Cataloging-in-Publication Data

Harnischmacher, Cyrill.
[Close-up shooting. German]
Closeup shooting : a guide to closeup, tabletop, and macro photography /
Cyrill Harnischmacher ; [translation, Christina Schulz]. -- 1st ed.
p. cm.
ISBN 978-1-933952-09-3 (alk. paper)
1. Photography, Close-up. I. Title.
TR683.H3713 2008
778.3'24--dc22
2008011237

My thanks go to Urte, Tabea, Jona, Ingrid, Kai, Bettina, and to all those who have contributed to this book one way or another.

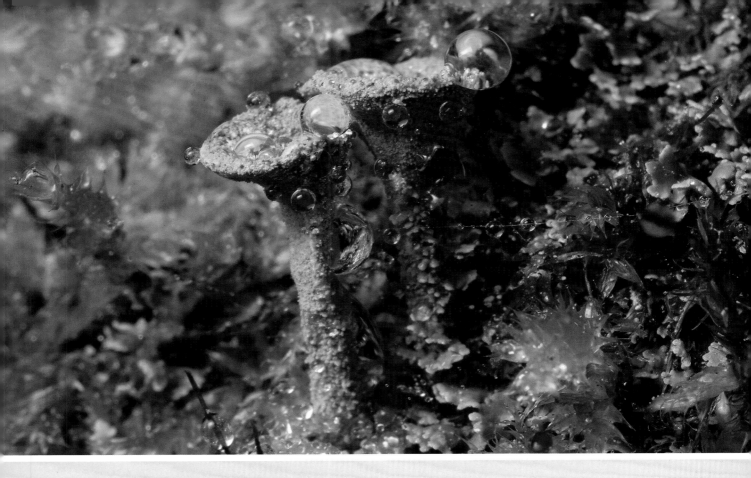

▲ *Moss. 1/125 sec at f/13; 50mm macro lens with 2x converter; off-camera flash with softbox. The moss was sprayed with water shortly before this image was taken.*

# Insights into New Worlds

One of the most fascinating areas of photography is closeup photography. Each step taken further into its depths is a step into a new world. Crystal clear globes may appear to hang weightless in space and seem to defy the laws of physics; we meet bizarre creatures that appear as though they came from other planets; and we discover master achievements in architecture which any engineer or architect would envy. This world lies directly before our eyes, yet it is so small and frequently so fleeting we cannot perceive it solely with our senses. Thus, closeup photography can be a journey into the unknown where new discoveries are constantly made, even after years of exploration. By using light, aperture, and creativity combined with the imagination of the photographer, new visual worlds can be created. Even common, everyday objects can be depicted in an exclusively unique way. Macro photography is defined as: "The making of photographs in which the object is either unmagnified or slightly magnified up to a limit often of about 10:1". Also, "Macro photography is defined as any photo in which the subject has at least a 1:1 ratio with the photo negative, meaning that the image on the negative of the subject is exactly the same size or larger than the real life subject". Closeup photography is defined as: "A photograph taken at close range". There is no pre-defined demarcation of exactly where the closeup range ends and where macro photography begins. The term "closeup" encompasses not only closeup photography, but macro and tabletop photography as well. Therefore, in the interest of consistency, the term "closeup" will be used in lieu of alternating between "closeup", "tabletop", and "macro". Closeup and tabletop photography also differ from macro photography in that the attraction of closeup and tabletop photography is more about designing, whereas macro photography is more about discovery. The image of a butterfly, which fills the picture format, will be considered by most people macro, even when the magnification is 1:3. A box of matches shown at the same ratio would more likely be considered a closeup image. The size of the objects being photographed, in conjunction with our habits of seeing, shape our perceptions too extensively to allow for a firm delineation between the two. The reason for this is based on our knowledge of the size of the box of matches. We can compare it to our learned notion of its size, whereas butterflies exist in many different sizes. However, my intention is not to elaborate on standard sizes in this book, but rather to focus on the opportunities available in the creative handling of modern technology in closeup photography.

In addition to covering the photographic and technical basics, a special emphasis is placed on how to handle lighting. Sometimes very minor lighting changes are necessary to make the leap from simply taking pictures to consciously creating great photographs.

Cyrill Harnischmacher

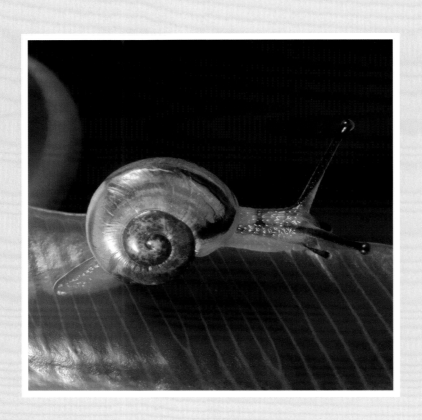

# Contents

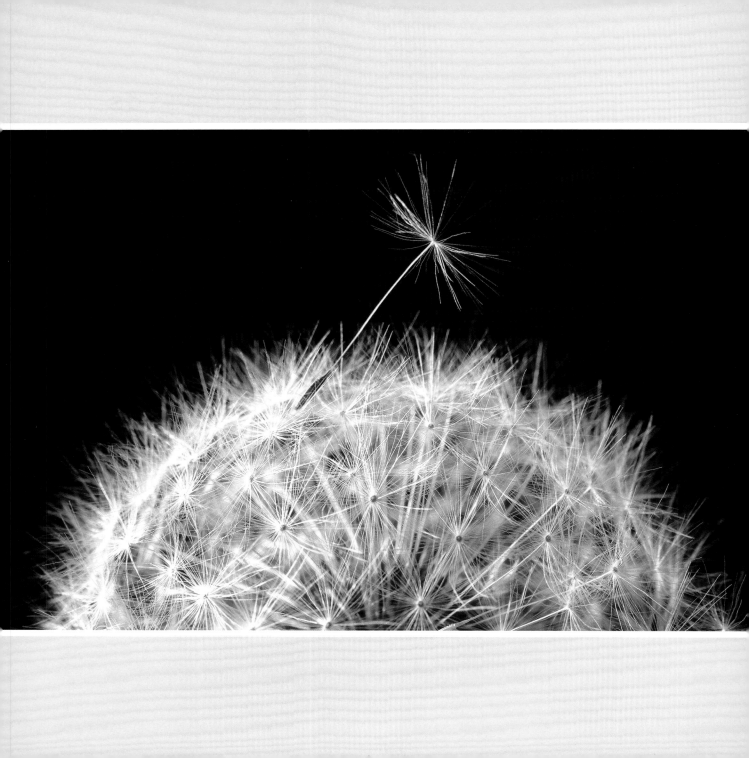

In order to achieve consistently pleasing results, you should become familiar with some of the basics, and learn how to use them purposefully in the creative design of your images. We will first take a look at the terms which recur in the art of closeup photography.

## Magnification Ratio

The magnification ratio describes the relationship between the actual size of an object and the size of its image on the film or sensor. A magnification ratio of 1:1 is reached when the object is reproduced in its actual size. This means 1cm in nature corresponds precisely to 1cm on the film or sensor, independently of the format used. When using a ratio of 2:1, the object will be illustrated twice as large as its natural size. Therefore, at a 2:1 ratio, 0.5cm in nature corresponds to 1cm on the film or sensor.

## Circles of Confusion

When a lens is focused, only those points which lie in the plane of focus will appear sharp on the film and/or sensor. All other areas of the image will not be shown as precise points, but rather as circles, called circles of confusion. To a certain degree, our perception will accept these circles as sharply focused. If the size of the circles exceeds this degree, we

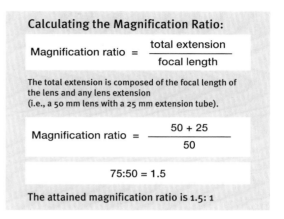

**Calculating the Magnification Ratio:**

$$\text{Magnification ratio} = \frac{\text{total extension}}{\text{focal length}}$$

The total extension is composed of the focal length of the lens and any lens extension
(i.e., a 50 mm lens with a 25 mm extension tube).

$$\text{Magnification ratio} = \frac{50 + 25}{50}$$

$$75:50 = 1.5$$

The attained magnification ratio is 1.5: 1

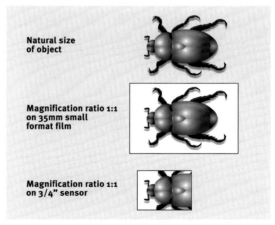

**Natural size of object**

**Magnification ratio 1:1 on 35mm small format film**

**Magnification ratio 1:1 on 3/4" sensor**

▲ *The magnification ratio is completely independent of the camera format.*

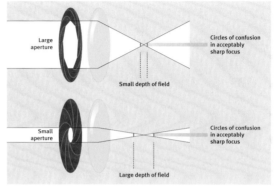

▲ *The shape of the circles of confusion is determined by how many segments the shutter has, (the sample shows 6 segments) and the way in which it is constructed.*

▲ *The larger the aperture, the smaller the perceptible depth of field. This is determined by the size of the circles of confusion.*

interpret them as out of focus. The camera format dictates how large the circles can be, and still be perceived as sharply focused. The shape of the circles of confusion has no influence on depth of field; the shape of the circles are determined by the shape and number of shutter segments. Ideally, the shutter segments form a circular shaped aperture opening. This rather subjective measurement of quality is called "Bokeh."

### Depth of Field

Depth of field is the distance in front of and behind the subject that appears to be in focus. There is only a single distance at which a subject is precisely in focus, but focus falls off gradually on either side of that particular point, and there is a region in which the blurring is imperceptible. These are the areas in a photograph that the human eye will accept as sharp, and are known as "circles of confusion". The aperture setting determines both the shutter speed and the maximum depth of field. If you want to achieve a greater depth of field in your image, you must close down the aperture (a higher aperture number). Opening up the aperture (a smaller aper-

▲ *From left to right: 50mm, 105mm, and 150mm macro lenses, using the same magnification ratio of 1:3, each at aperture 5.6. The depth of field is the same in all three cases. Using the same magnification within the macro range, the* *influence of the focal length on the depth of field will be offset by a change in distance. The picture taken with the telephoto lens shows a significantly smaller portion of the background due to the different viewing angle.*

**Table: Depth of Field for 35mm small format film**

| Magnification | aperture 2.8 | aperture 4.0 | aperture 8.0 | aperture 16 | aperture 22 |
|---|---|---|---|---|---|
| 1:4 | 3,4 mm | 4,8 mm | 9,6 mm | 19,2 mm | 26,5 mm |
| 1:3 | 2,0 mm | 2,9 mm | 5,8 mm | 11,5 mm | 15,9 mm |
| 1:2 | 1,0 mm | 1,4 mm | 2,9 mm | 5,8 mm | 7,9 mm |
| 1:1 | 0,3 mm | 0,5 mm | 1,0 mm | 1,9 mm | 2,6 mm |
| 2:1 | 0,1 mm | 0,2 mm | 0,4 mm | 0,7 mm | 1,1 mm |
| 4:1 | 0,05 mm | 0,03 mm | 0,15 mm | 0,3 mm | 0,4 mm |

Calculated with: Depth of Field, magnification ratio, and macro lens calculator, values rounded. http://www.erik-krause.de/schaerfe.htm
For your own calculations you can find a depth of field calculator at www.dofmaster.com/dofjs.html

ture number) results in less depth of field. Both sharpness and blurring are important aspects in design. Because of this, many single-lens reflex (SLR) cameras feature a depth of field preview button, which can be used to visually check the appearance of the depth of field at various aperture settings before shooting the photograph. Last by not least, the focal length of the lens usually affects the depth

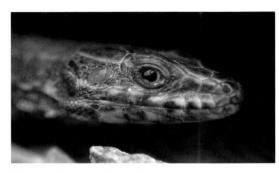

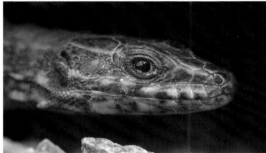

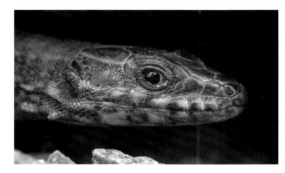

of field. Wide-angle lenses can achieve a greater depth of field compared to telephoto lenses. However, this is effective only if the camera remains at the same distance from the object. If the magnification ratio is the measure of things, as in closeup photography, the focal length has no influence on the depth of field when given the same magnification and aperture (see illustration on page 11). If you want to maintain the same image size with a different focal length, you need to change the distance from the object. In the closeup range, this will completely offset the influence of the change in focal length. If the distance from the object remains constant, the depth of field will change with different focal lengths. The magnification ratio and area shown in the image will also change, which means a larger portion of the view will be shown in the photograph. The object will be displayed as either larger or smaller on the film or sensor, depending on the focal length of the lens.

*Top: 300mm telephoto macro lens; 1/250 sec at f/5.6. Despite the shallow depth of field the camera can be handheld in a crunch.*

*Middle: 1/90 sec at f/9.5.*

*Bottom: 1/15 sec at f/19. Not possible without a tripod.*

## Relation of focal length, depth of field, and distance to object

| Focal length | aperture | depth of field | distance to object | approx. magnification | film plane |
|---|---|---|---|---|---|
| 150 mm | 8 | 5,8 mm | 80 cm | 1:3 | 10,8 x 7,2 cm |
| 100 mm | 8 | 5,8 mm | 53 cm | 1:3 | 10,8 x 7,2 cm |
| 50 mm | 8 | 5,8 mm | 27 cm | 1:3 | 10,8 x 7,2 cm |

| Focal length | aperture | depth of field | distance to object | approx. magnification | film plane |
|---|---|---|---|---|---|
| 150 mm | 8 | 1,0 mm | 60 cm | 1:1 | 3,6 x 2,4 cm |
| 100 mm | 8 | 8,3 mm | 60 cm | 1:4 | 13,3 x 8,8 cm |
| 50 mm | 8 | 5,1 cm | 60 cm | 1:10 | 36 x 24 cm |

Calculated with: Depth of Field, magnification ratio, and macro lens calculator, values rounded. http://www.erik-krause.de/schaerfe.htm
For your own calculations you can find a depth of field calculator at www.dofmaster.com/dofjs.html

## Camera Format

Smaller formats (such as the 1/2.5" sensors), which are found in digital compact cameras, can provide a larger depth of field in comparison to the smaller depth of field obtained by the significantly larger sensors of digital single-lens reflex (DSLR) cameras, and in small format film. This is due to the fact that in order to fill the frame with an object in various formats, you need to use a different magnification ratio, which results in a different depth of field. A magnification ratio of 1:2 can be used to fill an 18mm wide sensor with the image of a beetle that is 36mm long. As a result, an aperture of 8 will give a depth of field of 2.4mm. To fully show the same beetle on small format film (36mm), a magnification ratio of 1:1 is required, which results in a smaller depth of field. In this case, an aperture of 8 results in a depth of field of 0.96mm.

## Aperture and Diffraction

Since the depth of field can shrink to a fraction of a millimeter with an increase in magnification, you may be tempted to correct this problem by stopping down the aperture to its technical limit. This makes sense up to a certain point. When going beyond this limit, there is a general loss of sharpness due to the bending of light rays on the diaphragm opening. This effect is called diffraction. While diffraction is also

present when the aperture is wide open, it is negligible since most rays of light will pass through the rather large shutter opening in a straight line.

### Aperture and Diffraction

| Magnification ratio | minimum working aperture |
|---|---|
| 1:2 | 32 |
| 1:1 | 22 |
| 2:1 | 16 |
| 3:1 | 11 |
| 4:1 | 8 |
| 5:1 | 5,6 |

▲ *Stopping down beyond the minimum working aperture leads to a loss of sharpness due to the diffraction of light on the edge of the diaphragm opening.*

### Shutter Speeds

When the aperture is stopped down shutter speeds will increase. The same amount of light now needs more time to pass through a smaller shutter opening. As you advance further into the closeup range, more challenges are created with the extension of the lens, causing an additional loss of light. You can observe this phenomenon if you set your camera to aperture priority mode, and while keeping the same aperture, focus on an object at different distances within the closeup range. The shutter speed displayed in the viewfinder will get longer the closer you get to the object. Because of the resulting loss of light due to both stopping down and lens extension, you will quickly reach the point at which your shutter speeds will become too slow to hand-hold the camera, making camera shake inevitable. In order to reach acceptable shutter speeds you have two options. One solution is to change the lighting situation by adding more light e.g., with reflectors or with a flash. Alternatively, you can change the light sensitivity by increasing the ISO value. However, increasing the ISO degrades the image quality as the image becomes grainier, and shows more noise. Lastly, you can mount the camera on a tripod in order to work with longer exposures. Use of a tripod is the optimal solution when a stationary object is being photographed, thus eliminating the possibility that the picture will show motion blur.

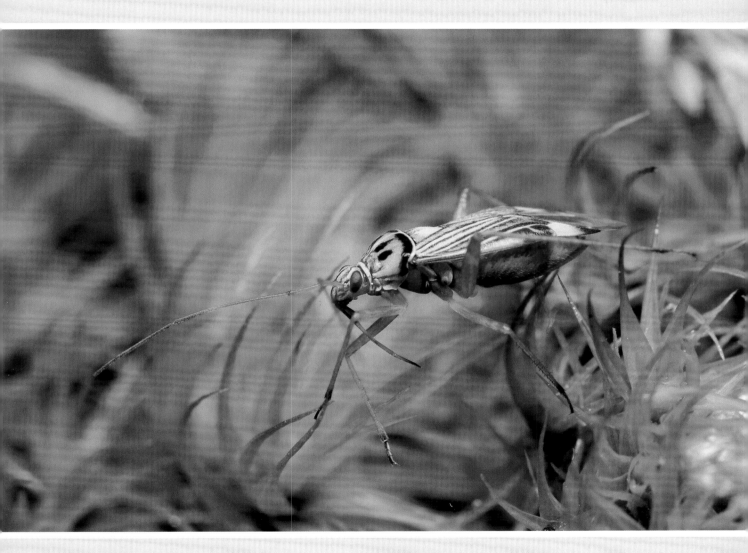

▲ *Calocoris quadripunctatus.*
*1/60 sec at f/9.5; 105mm macro*
*lens; flash with softbox.*

*We may meet bizarre creatures*
*which appear as if they are from*
*another planet.*

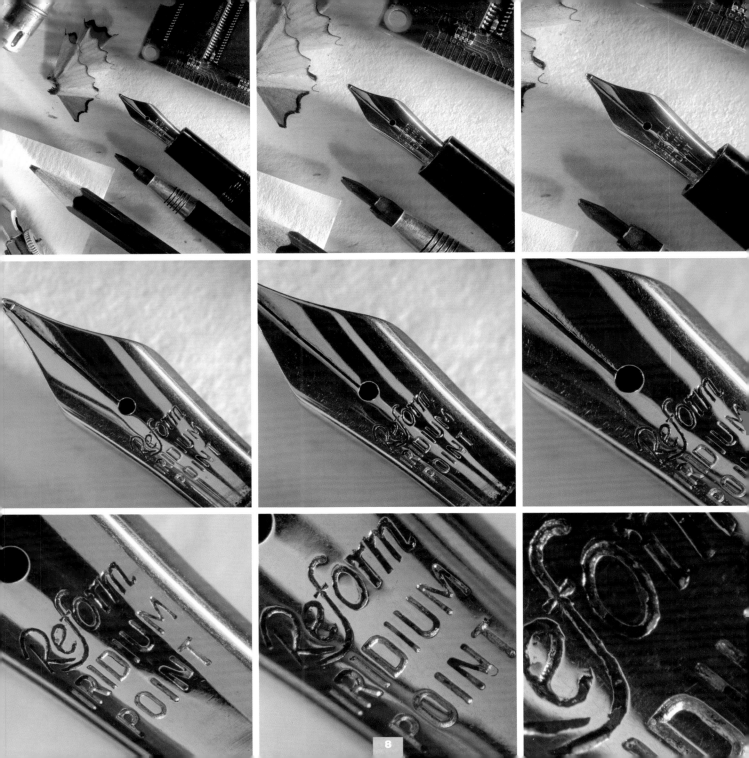

# Extreme Closeup

A true macro lens can range from a magnification ratio of 1:1 to the magnification ratio achieved when the lens is focused at infinity, while yielding high quality images without any optical aids.

The depth of field decreases significantly with an increase in magnification. Decent quality images beyond 1:1 can only be achieved with an SLR camera and specialty equipment.

| | | |
|---|---|---|
| *Standard zoom lens with macro mode at 70mm\** | *Standard zoom lens with macro mode at 70mm\*, close-up lens +2 diopters* | *50mm standard lens\* with 12 mm extension tube* |
| *Standard zoom lens with macro mode at 70mm\*, close-up lens +10 diopters* | *Macro lens 105mm, magnification ratio 1:1* | *Macro lens 105mm, close-up lens +4 diopters* |
| *Macro lens 50mm with 2 x converter, magnification ratio 2:1* | *90mm macro lens with bellows, maximum extension* | *35mm lens reversed with bellows, maximum extension* |

*\*Depending on close focusing distance (i.e., the closeup functions of the lens), the magnification ratio that can be attained will vary.*

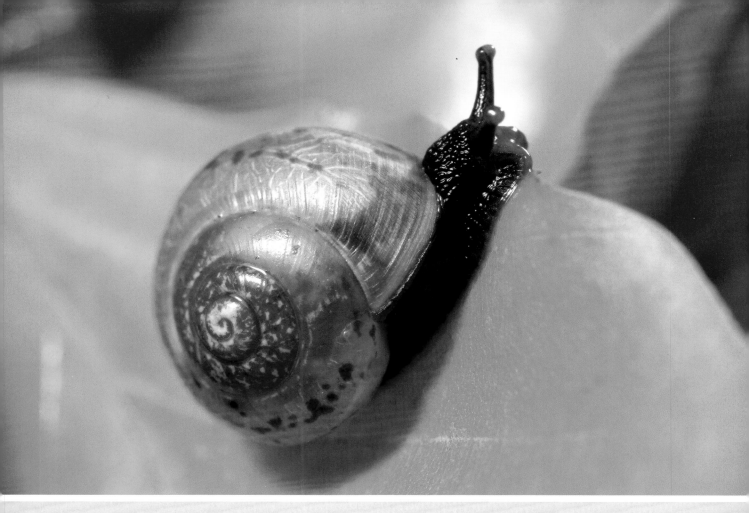

▲ Snail on fall foliage. 1/60 sec at f/16; 105mm macro lens; TTL-controlled flash with softbox.

By using the softbox you apply a light source that is far larger than the object and therefore create a pleasant soft light.

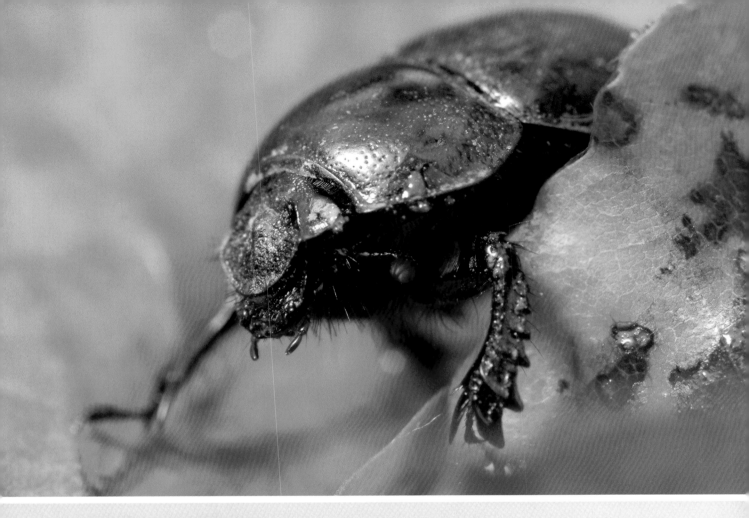

▲ Dung beetle in the autumn
forest. 1/60 sec at f/11; 105mm
macro lens; TTL-controlled flash
with softbox.

12

# Choosing the Right Camera

Through the success of digital cameras the potential for closeup photography has changed dramatically. Some digital compact cameras now achieve image results that are comparable with expensive, past-era specialty equipment, which usually required a large budget. The following information will give you an overview of the most common camera systems and their uses in closeup photography. In addition to resolution, purchase price, and close focusing distance, choosing the right camera also depends on personal preference. The ergonomics of the adjustment controls can indirectly have a substantial influence on image quality. Your creative pursuits may be hindered if the controls are too small or scattered, and/or the manual control mode is only reached after navigating through several submenus. Therefore, before purchasing a camera it is particularly important that you test the camera of your choice at a camera store or a tradeshow, or try one owned by a friend or acquaintance. For those who already own a camera, this book serves as a reference on how far you can immerse yourself into macro photography with your existing equipment, and which accessories can significantly extend your camera's closeup range.

### Analog Compact Cameras

Analog compact cameras are easy to use, however, they are quite unsuitable for closeup photography. One reason for this is the "parallax error", which means that at closeup focusing distances, the viewfinder will depict a slightly offset representation of the subject, when compared to the actual image as viewed through the lens. Furthermore, the attainable enlargement of the image does not truly fall into the closeup range for most of these camera models. Since analog compact cameras have been almost completely replaced by digital compact cameras, they are mentioned here only for the sake of completeness.

### Digital Compact Cameras

Digital compact cameras are available with many options. The most common digital compact cameras generally offer a good closeup mode. However, as opposed to the lenses of SLR cameras which refer to the magnification ratio as the measurement scale, digital compact cameras specify the minimum allowable distance to the object. At first sight, the label "macro to 1 cm" seems seductive, but usually this can be reached only in the wide-angle range. The very short distance required between the camera

and the subject makes supplementary lighting nearly impossible without the camera inadvertently blocking the direction of the light. The closeup capability in the telephoto range is of greater importance. Most digital compact cameras with closeup mode yield a maximum magnification ratio of roughly 1:2. To advance further into the closeup range, the camera must have a filter thread on the lens, allowing for a closeup lens to be attached. Many manufacturers solve this problem with an adapter tube onto which a zoom lens may fit. The viewfinder of a digital compact camera has the same limitations as an analog compact camera. This is inconsequential during use, because the digital camera display can be used as a substitute. On models with a display that can swing out and swivel, pictures can be taken close to the ground or from a frog's perspective without having to look through the viewfinder. Manual focusing is a weak point in most of these cameras. Focus is often achieved by the use of a toggle switch, which limits the sensitive placement of the focusing point. Due to the significantly smaller imaging format, a much larger depth of field is achieved with a compact digital camera than with an SLR camera, which should appeal to friends of scientific photography, where it is important for the entire subject to be sharply focused.

### Digital Bridge Cameras

A niche product during analog times, digital bridge cameras have now become more popular for good reasons. Handling is similar to an SLR camera, they fit well into your hand, and generally, the focal length and focus can be manually modified with an adjustment dial on the lens. Most models offer a high to very high resolution, and many include a standard image stabilizer, as well as displays that can tilt and swivel. The electronic viewfinders are of high quality, yet do not compare to the sharpness and brilliance of optical viewfinders. Nevertheless, they are foldable and therefore can double as a right-angle finder. The closeup range lies between 1:4 and 1:2 without any further aids. Cameras with image stabilizers and a substantial zoom range are especially suited for photographing insects approximately the size of a butterfly. If you want greater image magnification, and your camera lens has a filter thread, your only choice is the use of supplementary closeup lenses, as the standard lenses are not interchangeable. With a supplementary closeup lense you can reach magnifications of 1:1, and even a little more in come cases.

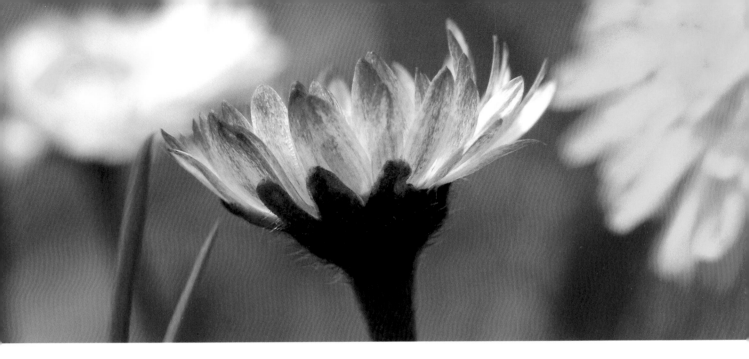

▲ *Daisy in spring meadow.*
*Digital bridge camera, 1/640 sec at*
*f/7.1, 50mm, ISO 100, closeup lens*
*+4 diopters.*

*Together with a supplementary*
*closeup lens you can approach a*
*magnification of 1:1, assuming you*
*have a filter thread on your lens.*

### Digital Single-Lens
### Reflex Cameras

No other camera system offers options as versatile in the close-up range as do digital single-lens reflex (DSLR) cameras. This is one reason why this book is primarily devoted to the use of this type of equipment. If you have high expectations of image quality and lens extension choices, and/or you want to advance beyond the magnification ratio of 1:1, you cannot

avoid using an SLR camera. In the closeup range in particular, multiple solutions may be found for almost any photographic problem, ranging from closeup lenses to sophisticated flash control options. This flexibility comes with a price tag, as every accessory must be purchased separately. This includes lenses, right-angle finders, and bellows, to name a few. A disadvantage of the DSLR is the sensor's high sensitivity to dust because it is unprotected. Changing the lens during pollen season in spring can

leave visible traces on the sensor. Even zoom lenses and bellows can produce much unwanted dust. Normally, you can dispose of the dust with the help of an air blower or a special cleaning solution. Most SLR cameras have a smaller imaging area compared to small format (35mm) film, which results in the equivalent of a focal length extension of 1.5. This means that a 150mm closeup lens will effectively turn into a 225mm lens. The focal length extension has no influence over the attainable magnification, but it does affect shutter speeds, and thus gives you the option to handhold without any blurring.

### Analog Single-Lens Reflex Cameras

Analog SLR cameras also work very well for closeup photography. The older models in particular, have an extensive list of equipment available, such as high quality closeup lenses, bellows, etc. Often, these items can be purchased used at low prices. It may seem a little slow or awkward to work without the immediate accessibility of the digital picture preview screen, but this has no bearing on the quality of the images. Many nature photographers still prefer the image quality and color reproduction of high quality slide films and they value the robust reliability of these cameras. Thus, consideration of analog cameras is still justified, especially for use in closeup photography.

*A manual SLR camera does not belong in the antique store. Used equipment and lenses are often inexpensive to purchase.*

## Cameras Useful for Closeup Photography

Legend:
- **+** perfect
- **●** well suited
- **○** limited use
- **✗** not suitable

| | Analog Compact Cameras | Digital Compact Cameras[1] | Digital Compact Cameras, Manual Mode[1] | Digital Compact Camera with Closeup Lens[2] | Digital Bridge Cameras[1] | Digital Bridge Cameras with Closeup Lens[2] | SLR/DSLR, Standard Zoom Lens with Macro[3] | SLR/DSLR, Standard Lens with Closeup lens[2] | SLR/DSLR, 50mm Lens with Extension Tubes | SLR/DSLR with 50mm/60mm Closeup Lens | SLR/DSLR with 90mm/100mm Closeup Lens | SLR/DSLR with 150mm/180mm Closeup Lens | SLR/DSLR with Wide-angle Zoom, Reversed[4] | SLR/DSLR with Bellows[3] | |
|---|---|---|---|---|---|---|---|---|---|---|---|---|---|---|---|
| | ○ | ○ | ● | ● | ● | ● | ● | ● | ● | + | + | + | ✗ | ○ | up to magnification 1:2 |
| | ✗ | ✗ | ✗ | ○ | ✗ | ○ | ✗ | ○ | ● | + | + | + | ● | ● | up to magnification 1:1 |
| | ✗ | ✗ | ✗ | ✗ | ✗ | ✗ | ✗ | ✗ | ✗ | ✗ | ✗ | ✗ | + | + | up to magnification 2:1 and beyond |
| | ✗ | ○ | ○ | ● | ● | ● | ● | ● | ● | ● | + | + | ● | ● | smaller animals/insects |
| | ○ | ○ | ● | ● | ● | ● | ● | ● | + | + | + | + | + | + | plants/flowers |
| | ○ | ○ | ● | ● | ● | ● | ● | ● | + | + | + | + | ○ | ● | technical/jewelry/collections |
| | ○ | ● | ● | ○ | ● | ○ | ○ | ○ | ○ | + | + | + | ○ | ✗ | underwater closeup photography[5] |

[1] depending on close focusing distance
[2] depending on close focusing distance and close-up lens
[3] depending on macro mode of the lens
[4] depending on lens
[5] additional body or special camera needed

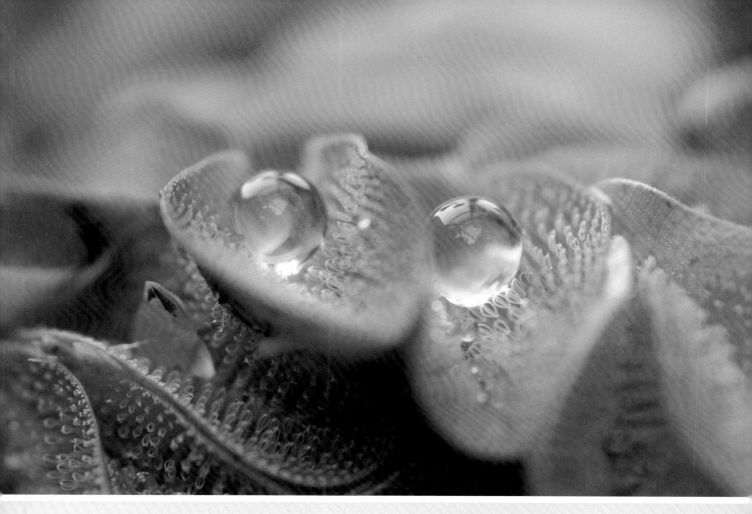

▲ Dew drops on water plant.
1/250 sec at f/2.8; 105mm macro
lens; ISO 1600.

Modern digital cameras can reach
acceptable image quality even with
high ISO settings, so that you can
still shoot handheld even under poor
lighting conditions.

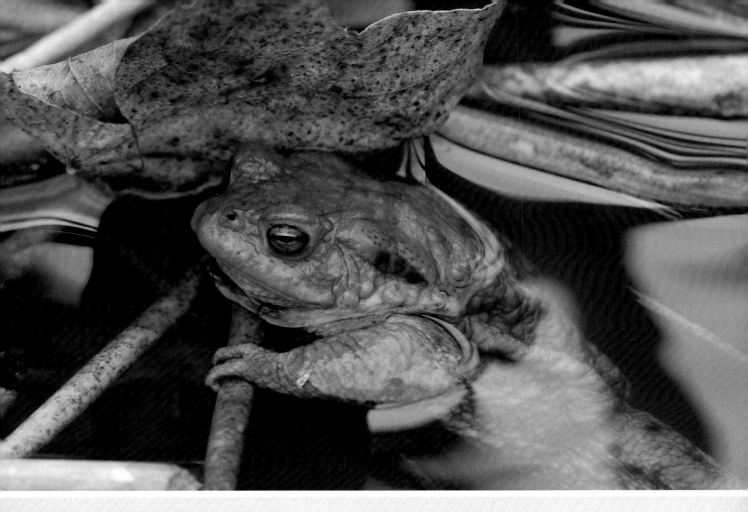

This is especially important when using a long focal length, or if there is not enough space to set up a tripod.

▲ Toad. 1/500 sec at f/4; 150mm macro lens; ISO 800.

# Standard Lenses

Zoom lenses belong to the basic equipment of an SLR camera, and you will be hard pressed to find one without a macro mode. The term "macro" can be misleading; therefore, it would be preferable to talk

▲ *Flower umbel. 1/250 sec at f/5.6, ISO 200; standard zoom lens at 70mm; macro mode; exposure correction 0.5 stops. Standard zoom lenses with macro mode are well suited for your first steps into closeup photography.*

about close focusing distance. Magnifications up to 1:2 allow you to completely fill the image sensor with many subjects, such as butterflies, flowers, and mushrooms. Since most available zoom lenses are slow and the macro mode is usually only accessible in the telephoto range, hand-holding the camera can become impossible without noticeable motion blur. You can continue to progress further into macro photography with extension tubes and closeup lenses; however, the results strongly depend upon the photographic lens used. A high quality, fast zoom lens can produce wonderful results coupled with an achromatic lens. An achromatic lens is a combination of lenses, often fused into a single lens, made from materials of different refractive indexes. It is constructed in such a way as to minimize the colored "halos" around images, which is due to lens diffraction at different wavelengths in white light, known as chromatic aberration.

# Closeup Lenses

A high-quality closeup lens can be a companion for life. With it you can produce images up to magnifications of 1:1 without needing any additional equipment. The focal length you choose depends solely on the type of images you want to create. Focal lengths of 50mm or 60mm are ideal for reproduction work, because they are flat-field lenses (rendering an image that is as sharp on the edges as it is in the center). They are also well-suited for macro photography when you do not need a long focusing distance, such as when photographing plants in the studio. The versions ranging from 90mm to 105mm are a good compromise for all macro imaging needs. These have greater focusing distances that allow for supplementary lighting of the subject. While using them with a medium aperture, the camera can still be handheld. The Nikon AF-S VR Macro 105mm/2.8G IF-ED stands out in its class, because it is the first

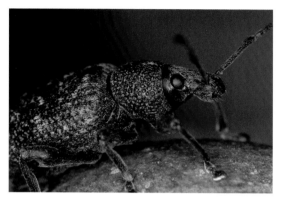

▲ *Hylobius abietis. 1/60sec at f/9.5; 105mm macro lens; TTL ring flash*

lens to offer an image stabilizer in the macro range. To photograph insects, focal length lenses of 150mm to 200mm are ideal. The working distance of approximately 30cm (12 in.), calculated from the front-most element of the lens, is large enough to prevent the scaring away of most insects. A true macro zoom lens is the Nikon AF Macro 70-180mm / 4.5-5.6D ED. This lens is not as fast as the fixed focal length lenses, but offers a maximum magnification of 1:1.32.

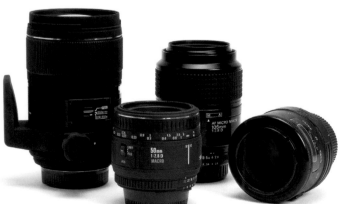

*Macro lenses exist almost exclusively as fixed focal length. In image quality, they are superior to standard zoom lenses.*

# Extension Tubes & Teleconverters

Extension tubes, as the name implies, are added between the camera body and the lens. They have no optical elements of their own, and only lengthen the extension of the lens. The advancement into the closeup range is only possible step-by-step through the combination of different extension tubes, which can prove to be somewhat cumbersome in the field. With an extension of 50mm, a magnification of 1:1 can be reached with a normal lens of 50mm. The image quality will strongly depend upon the lens used. Good results with a magnification ratio greater than 1:1 can be achieved when combining an extension tube with a macro lens. For practical purposes, we only recommend automatic extension tubes which transfer all functions between the camera and the lens.

A teleconverter changes the focal length of the lens by a certain factor through an optical system. For closeup photography this means that at the same focusing distance the picture will become larger on the film plane or sensor by the factor of the converter. If the same magnification ratio is kept, the focusing distance changes correspondingly. A 50mm closeup lens with a magnification of 1:1 will become a 100mm closeup lens with a magnification of up to 2:1 in combination with a 2x teleconverter.

If the magnification ratio of 1:1 is kept, the focusing distance to the subject doubles. Teleconverters are an economical alternative to the much more expensive telephoto closeup lenses. Since teleconverters reduce the amount of light that reaches the film plane, they should not be used under low light conditions. Expect to open up the aperture 2 stops with a 2x teleconverter, and approximately 1 stop with a 1.5x teleconverter. The viewfinder will also dim by the same factor. Some teleconverters are specifically made for certain lenses; this combination may result in very high image quality. In contrast to extension tubes, teleconverters do not cause lenses to lose their ability to focus on infinity.

*Teleconverters extend the focal length, but they also affect the image quality of the lens.*

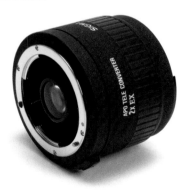

# Reversed Lenses

A lens can be mounted in a reversed position to the camera faceplate with an adapter ring. The possible magnification ratio with a 35mm lens will be approximately 1:1, and about 3:1 with a 20mm focal length. An adapter ring has a lens mount on one side and an external thread on the other side. When using an adapter ring, all automatic camera controls are lost, including control over the aperture, which makes working more difficult. Although you can focus adequately with an open aperture, you must manually stop down to take the picture. This darkens the viewfinder to an extent where it can be difficult to see the shifting point of focus when moving the camera. An alternative for owners of Canon EOS cameras is the Novoflex reverse adapter. It uses a cable and a second adapter ring to retain most available functions.

With the use of stacking rings, a second lens in reversed position may be attached in front of the primary lens, taking on the function of a high quality closeup lens. Stacking rings have two sets of threads in order to connect the lenses (front to front). It is best to use a wide-angle lens with a large aperture in the reversed position. If the opening is too small, the image frame may not be filled in its entirety or will be clearly vignetted.

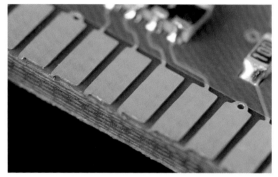

▲ *Detail of a memory chip. The thickness of the circuit board is 1mm. 1/125 sec at f/8; 35mm lens; reversing ring and 31mm extension tube; studio flash with softbox.*

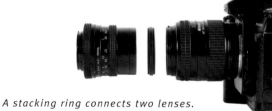

*A stacking ring connects two lenses. The front lens transforms into a high quality macro lens. (This is also possible with digital bridge cameras as long as they come with a filter thread on the lens).*

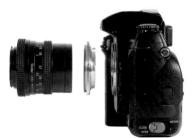

*With a reversing ring, lens can be mounted reversed the camera faceplate and used as macro lenses.*

# Bellows

Bellows are used to lengthen the extension of the lens by continuous adjustments, as opposed to the step-by-step process of extension tubes. Just like extension tubes, bellows do not influence the image quality of the lens because they do not have an optical system. Because extreme magnification ratios can be reached, it is often necessary to stop down significantly to acquire an acceptable depth of field. This leads to problems with diffraction. Besides specially developed lenses for bellows, closeup lenses with a focal length of 100mm are well suited for use with bellows. These lenses offer a working distance from the object that is long enough to set up effective lighting. Normal and wide-angle lenses should be attached in reverse. The bellows from Novoflex are particularly practical as they transfer the aperture settings to the camera, enabling you to work intuitively with a bright viewfinder. When combined with a flash, the camera may even be handheld. A disadvantage of all bellows devices when coupled with a DSLR camera is that the dust which tends to settle in the folds of the bellows may easily contaminate the image sensor. Therefore, it is important to clean the bellows thoroughly with an air blower before attaching them to the camera. Depending upon the extension and type of lens used, bellows devices allow for magnification ratios up to 6:1.

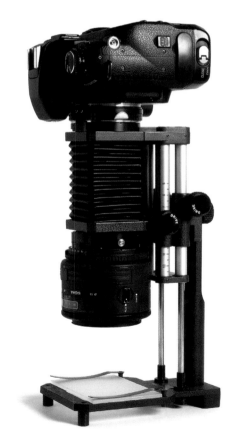

*Bellows allow magnification rates that go far beyond the ratio of 1:1. Some models even transfer the aperture setting so that you can focus with the aperture wide open, allowing for a bright viewfinder display.*

# Closeup Lenses

For digital compact and bridge cameras, closeup lenses are not only the least expensive, but are the only option for advancing into closeup photography. The focal length of the lens is shortened by simply screwing the closeup lens onto the filter threads. This allows for a shorter working distance from the subject, and therefore a larger representation on the film or sensor. The image quality depends not only on the quality of the closeup lens, but also on the photographic lens used. To achieve an optimal image quality, the lens should be stopped down by at least 3 stops. The best results are achieved with achromatic closeup lenses in combination with high quality fixed focal length lenses. Simple versions save you money but may not deliver good optical performance. Since clearly visible distortions and blurred edges can be present, these lenses should not necessarily be used for reproduction work. Closeup lenses also have many advantages. The speed of the lens is preserved, and therefore delivers a bright viewfinder image. They are lightweight, easy to handle, and can find space in every photo bag. They can be used in the wide-angle closeup range to create interesting perspectives.

*Closeup lenses come in different versions. Their strength is measured in diopters between +1 (slight magnification) and +10 (very high magnification).*

▲ *Together with a closeup lens (in this case +10 diopters), the standard zoom lens becomes useful for macro imaging. Because of the potentially powerful magnification, the shallow depth of field can be used as a creative element.*

# Specialized Equipment

## Zoerk Macroscope

The Zoerk macroscope is an aspheric, 2-element, top-notch closeup lens with +12 diopters. The image quality clearly overshadows many basic closeup lenses, depending upon the quality of the basic lens used. A magnification of 1:1 is possible with an 80mm lens and a focusing distance of about 6-9cm (2.5-3.5 in.). This distance falls below the flight response distance of many insects and animals, yet allows enough distance between the camera and the subject for a supplementary lighting setup. When the macroscope is paired with a basic lens in the wide-angle range it might lead to vignetting. Like all closeup lenses, the macroscope is directly attached to the filter thread of the lens with an adapter. It is especially practical for use with zoom lenses. Even with a macro lens it performs admirably, bringing the magnification far beyond the ratio of 1:1. In combi-

▲ *With help of the macroscope, even digital compact or bridge cameras can reach magnifications of 1:1 with a superb image quality.*

nation with a digital bridge camera and an image stabilizer, it produces a wonderful and compact solution for closeup photography while traveling. Find more information at www.zoerk.com.

## Canon Magnifying Lens

The Canon MP-E 65mm 1:2.8 1-5x Macro lens is a comfortable alternative to a bellows device. This magnifying lens is calculated for magnifications between 1:1 and 5:1, and thus, goes far into the closeup range with the highest image quality.

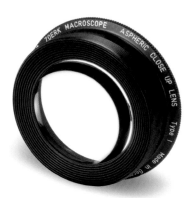

*The Zoerk macroscope is an aspherical, 2-element closeup lens of top-notch quality.*

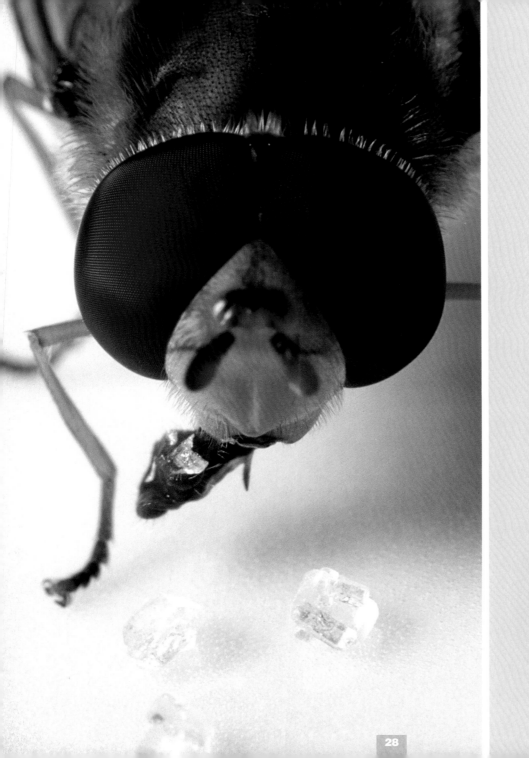

◀ *Fly consumes sugar. 1/125 sec at f/16; 50mm normal lens reversed on bellows; small flash LZ 22 manual with softbox. The depth of field is only a fraction of a millimeter, which makes it extremely difficult to pinpoint the optimal point of sharp focus. Here, the point of focus is on the sugar crystals as the most prominent detail in the picture. If it were to lie just slightly closer, e.g., on the edge of the fly's head, the sugar crystals would be out of focus.*

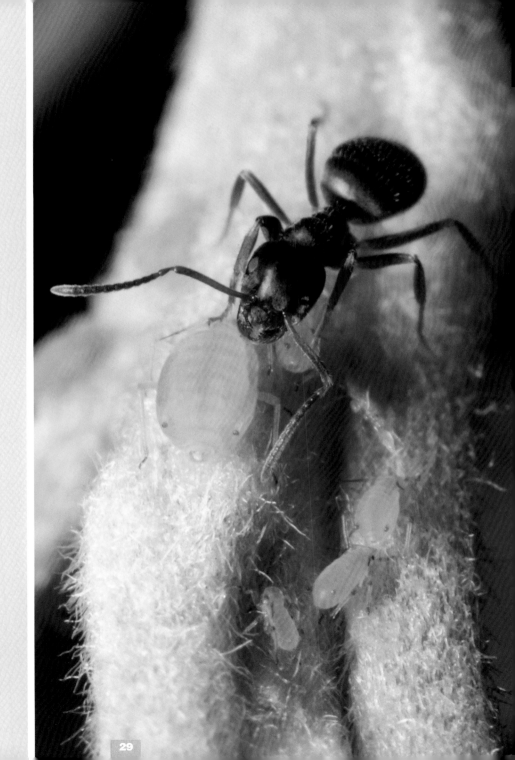

▶ *Ant and aphids on apple tree. 1/125 sec at f/13; 50mm macro lens with 2x teleconverter; flash with softbox. Images with a magnification of 2:1 or larger are only possible with an SLR camera and corresponding equipment.*

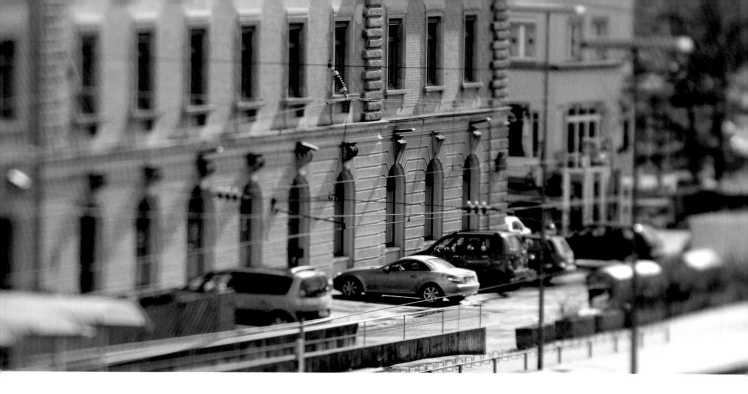

▲ *What appears to be a model lands-cape is actually a real street scene. The impression of a closeup picture* *arises by shifting the plane of focus and using a large aperture.*

The Zoerk Multi Focus System consists of a tilt tube, the Zoerk Mini Macro Mount, a camera adapter, and a lens head (generally an enlarger lens or large format lens). It provides up to 30 degrees of tilt and swing in any direction, similar to large format view cameras. Because of this you can adjust the plane of focus to suit your object; for example, across the whole length of a pencil lying diagonally. Alternatively, you can significantly increase the depth of field without having to stop down the aperture. The big advantage of this is the short

*By matching the plane of focus to the subject, the Zoerk Multi Focus System may permit a shutter speed that can be used with a handheld camera.*

# The Zoerk Multi Focus System

exposure time, allowing the system to be used while handholding the camera. Focusing is done through the Mini Macro Mount (a cone-shaped focusing tube), which has the advantage of continuous focusing adjustments (as is the case with bellows), combined with the stability and compact construction of an extension tube. Since the exposure is measured on the working aperture, it is best to use the Zoerk Multi Focus System on a camera that preserves the automatic exposure mode even with manual focusing lenses. However, this is not always a feature found on modern DSLR cameras.

*Top: At f/4.5 in normal position the depth of field is very shallow.*

*Middle: A vertical tilting of the lens shifts the plane of focus and extends the depth of field without changing the aperture.*

*Bottom: Through a horizontal swinging of the lens, the plane of focus is shifted.*

# Closeup Equipment

Sometimes more than two hands are needed to simultaneously hold the flash and the camera while positioning an additional reflector and focusing on the object. The following items can be very helpful in these situations.

**Accessory Stands**
Small stands with numerous clamps to hold small objects; also available with small loupe

**Air Blower**
To clean camera, bellows, and objects

**Brush**
With a small watercolor brush you can carefully remove dust from an object

**Building Blocks**
Ideal for supporting, lifting, etc.

**Cable Release, Remote Control, and Infrared Release**
These are important for avoiding camera shake while releasing the shutter, especially when using a tripod and mirror-lockup

**Cardboard**
To lighten (white), for shadows (black), for color effects (colored), or as a background, etc.

**Clamps**
To attach equipment, backgrounds, and decorations; paired with tripod socket to hold flash units

**Colored Foil**
Taped in front of the flash; creates interesting colored effects

**Cotton Swabs**
To clean hard-to-reach areas

**Eva Foam**
Use to cushion especially sensitive objects

**Flashlight**
Ideal for use as a "light brush" for creative lighting effects

**Flash Bounce Shoe Adapter**
Mounted between camera hot-shoe and flash; allows forward tilting of the flash

**Flash Brackets**
To mount the flash off camera; allows for better control over shadows

*A focusing rail permits sensitive and precise focusing.*

**Flash & Slave**

Used to supplement one flash unit with one or several more. The slave trigger activates the other units by "seeing" the first flash (using a phototransistor), and subsequently triggers the other flashes microseconds later

**Focusing Rail**

Focus on the object is set by moving the entire camera on the rail, rather than focusing with the extension of the lens; this allows for a precise positioning of the focal point

**Gray Card**

Standard card with gray surface; reflects the value of middle gray at 18%; helps to accurately measure exposures

**Ground Spike**

A special metal pin with tripod socket, which is used as an extra tripod to hold flash units or similar accessories; can simply be stuck into the ground

**Hot Glue Gun**

Hot glue dries fast and is easy to remove from hard, flat surfaces; ideal to affix something quickly

**Mirror**

Allows the lighting to be directed intentionally to a specific spot

**Modeling Clay**

Attaches objects in variable positions in the studio.

**Right-Angle Finder**

Attaches to the viewfinder eyepiece; redirects the viewfinder image by 90 degrees; allows for picture taking from unconventional perspectives. Best are the versions that can switch to 2x magnification, show the image right side up, and be rotated 360 degrees. Right-angle finders are already available in digital versions with small tilt and swivel LCD displays and zoom capabilities.

*With a used focusing rail, a clamp, and a few items from a home improvement store, you can quickly create a closeup-imaging table for compact digital cameras.*

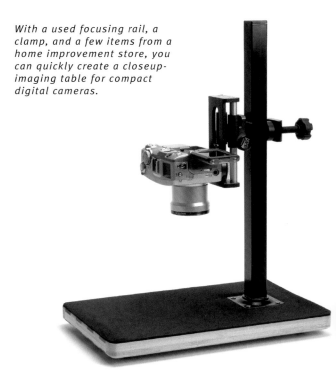

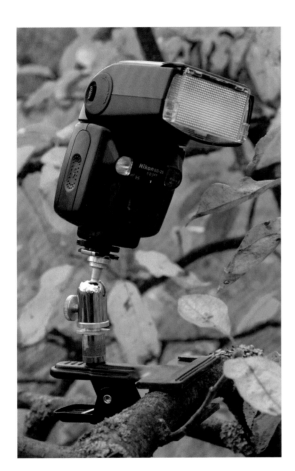

▲ *A clamp with a tripod socket and small ball head provide for a stable support. The flash is triggered through an integrated slave unit.*

**Reflectors**

Made of cardboard and silver or gold colored foil; used to lighten shadow areas

**Tabletop Tripod**

A tripod for a flash or for closeup imaging near ground level

**Tape**

Indispensable: double-sided tape, removable tape, etc.

**Tweezers**

Use to place or remove small pieces of the object during tabletop photography

**Viewfinder Loupe**

A loupe that can be attached to the viewfinder eyepiece to enlarge the viewfinder image and ease focusing

**White Balance Card**

White cardboard without optical brighteners to adjust the individual white balance for digital cameras

*With the universal clamps from Novoflex, cameras and accessories can be attached to pipes or similar supports.*

# Tripods, Tilts, and Ball Heads

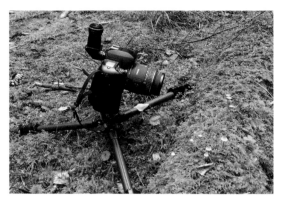

▲ A small, lightweight tripod to take images near ground level and a right-angle finder prepare you well for most closeup pictures.

▲ When using a longer focal length, especially in combination with a teleconverter, the tripod and ball head should be very stable.

Which tripod will I bring with me today? This question is truly necessary because there is no universal solution for all imaging situations. Depending upon the area of use, photographic preferences, and the type of camera, the requirements of a tripod can vary widely. If you predominantly photograph dragonflies and other shy insects with an SLR camera and a telephoto macro lens, your needs will be completely different than if you take pictures on your tabletop in the studio or shoot mushrooms at ground level with a digital bridge camera. Before purchasing a

*Some manufacturers offer special closeup tripods with bendable center posts.*

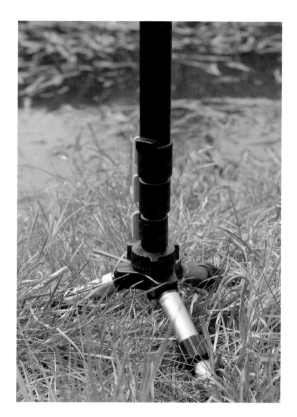

▲ Monopods can significantly reduce motion blur, but the danger exists of changing the focus on the subject by swaying the monopod. If you add a small tabletop tripod you can gain additional stability. Alternatively, you can use a monopod with a foot pedal.

tripod, consideration should be given as to your intended usage. In addition to the manufacturing quality, attention should be paid to the ergonomics of the tripod. A good tripod should be easy to set up, even in cold weather when you may be wearing gloves. A ball head or pan and tilt system should be interchangeable so that you are not limited to the attachments offered by the manufacturer. Ideally, all other components, e.g., the legs, should be available as additional components. Whether you choose a ball head or a 2 or 3 way pan and tilt head depends on your personal taste. The stability of the system is most important. If the combination of the camera and lens is too heavy, the pan and tilt or ball head can slowly readjust due to the weight of the equipment. This can be especially problematic when you are waiting from a distance (remote control in hand) for the desired butterfly to finally pause on the flower you have pre-focused on. Obviously, the weight of the tripod is an important factor in camera stability, but keep in mind that you would probably not want to bring a tripod into the field that is difficult to set up, even if it were light. If you find a tripod that meets all of these considerations while fitting your budget, you have found a companion for many years.

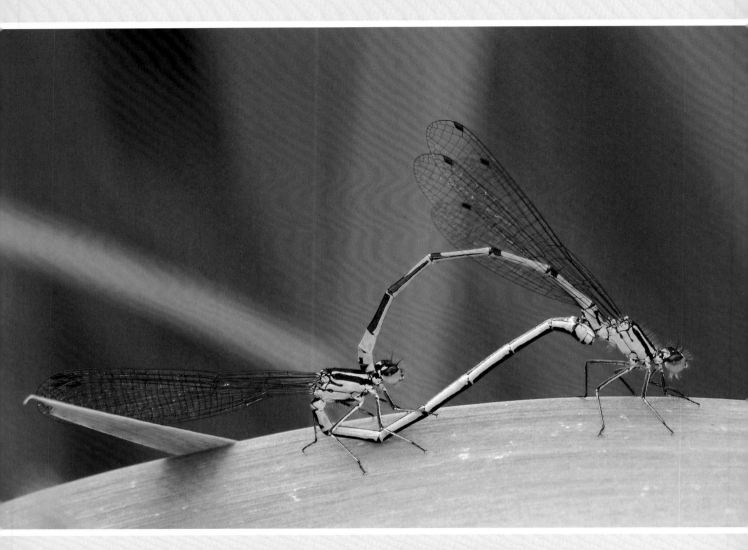

▲ *Coenagrion puella* mating. To pho-
tograph dragonflies, filling the frame
with a magnification of 1:3 is com-
pletely sufficient and is possible with
most modern telephoto zoom lenses
and/or bridge cameras. A tripod or an
image stabilizer is important. 1/90
sec at f/13; 300mm telephoto macro
lens; tripod; fill-in flash.

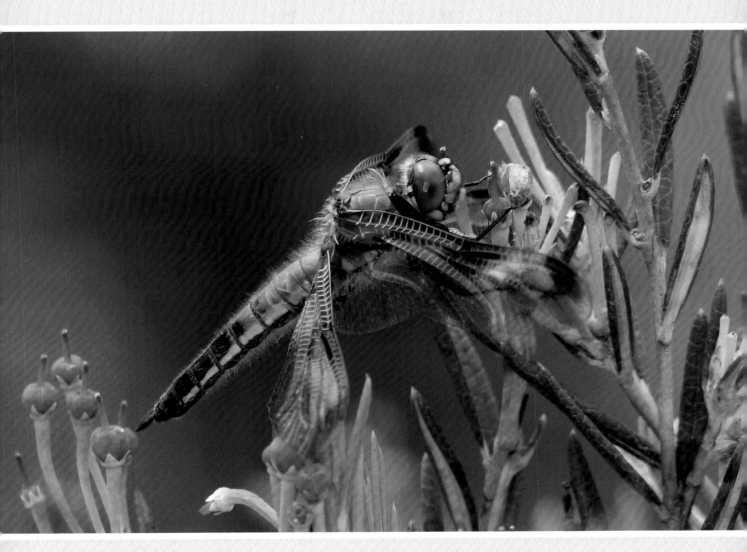

▲ *Libellula quadrimaculata. You can get quite close to this type of dragonfly because its tolerance for human presence is high.*

*1/90 sec at f/9.5; 300 mm telephoto macro lens; tripod; fill-in flash.*

# The Most Important Filters

Even in the age of digital photography, filters are not yet obsolete. Of course, you can achieve one or more effects after the fact with the help of photo manipulation software, but there are still some filters that should not be missing from any photo equipment bag.

**UV Filter**
Absorbs UV-light, the picture appears more brilliant; can be used to protect the lens.

**Skylight Filter**
For natural colors outdoors, reduces the blue tone; this filter can also be used to protect the lens.

**Polarizing Filter**
This filter can be rotated and reduces or removes reflections on water, glass, or other reflective surfaces. This allows you to take a picture of a window display without distracting reflections. In addition, the color of the sky is intensified and clouds appear more three-dimensional. To prevent false auto focus or exposure measurements, some cameras require circular polarizing filters instead of the more affordable linear polarizers.

**Warming Filters**
These are especially suited for portraits since they reproduce warmer, more natural skin tones.

**Neutral Density Filters**
A long exposure time will give moving water (such as

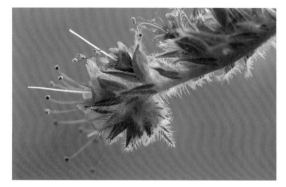

▲ *Gray filters allow for large apertures even under bright lighting conditions, which can help to separate the object from the background.*

a waterfall) the appearance of a more gentle and graceful flow. To achieve this effect even during bright daylight without changing the appearance of the colors, a gray filter is useful. With it, you can alternately select a wide-open aperture to reduce the depth of field.

**Graduated Filters**
Graduated filters darken only a portion of the image. They are particularly useful for bright skies in order to correctly expose the landscape in the foreground without over exposing the sky. Graduated color filters can add the appearance of a sunset into a normal landscape scene as if by magic.

### Special Effect Filters

Use of soft focus filters, color effects filters, and star filters are good options which may enhance a subject – but they should be used sparingly.

### Conversion Filters

These are used in analog photography, e.g., to use daylight films under neon or incandescent lighting situations. Since digital cameras include an option to set individual white balances, these filters have become mostly superfluous. Red, green, and yellow filters are used in black and white photography to block certain partial rays of light, while allowing for more contrast in the domain of portrait and landscape photography.

### Infrared Filters

Infrared photography has become considerably easier with digital cameras. Infrared filters block nearly all the visible light that would ordinarily pass through the lens, allowing only the close infrared rays through. Green, sunlit leaves will appear almost white, while a blue sky will appear black. Generally, very long exposure times are necessary.

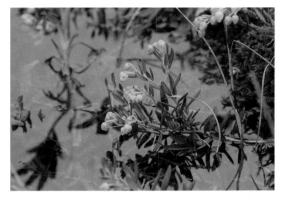

▲ *Without a polarizing filter, this image shows a strong reflection of the sky on the surface of the water.*

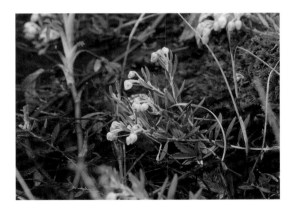

▲ *With the use of a polarizer the reflection can be almost completely removed. With a circular polarizer the photographer can select within a range, from the highest amount of glare reduction to only a slight reduction.*

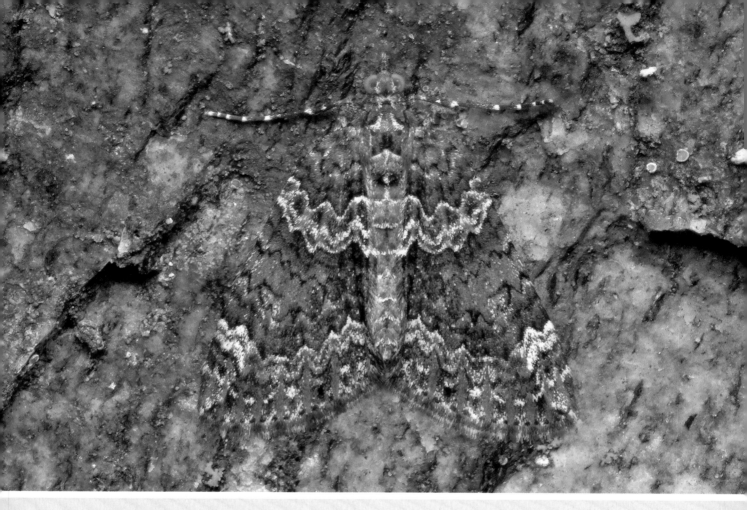

▲ *Olive-green butterfly. 1/60 sec at f/11; 50mm macro lens. To escape enemies (and photographers) many* potential subjects have become masters at camouflage.

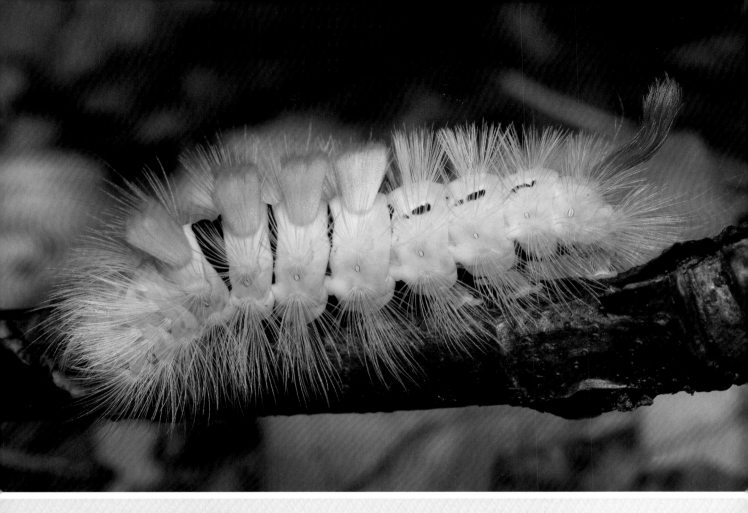

▲ *Caterpillar. 1/60 sec at f/8; 50mm macro lens; on camera flash with soft box; handheld.*

44

# Daylight

The word "photography" (when literally translated) means "light painting" [Greek: phos = light: graphein = write/paint]. This idea of painting with light is certainly valid in closeup photography. Light can create many disparate moods, and a change in lighting has a direct effect on the image statement. As a photographer you should always make an effort to control lighting and make necessary adjustments, because the camera "sees" a scene differently from the human eye. The film or sensor reproduces a relatively small range of colors; our own inner image interpretation corrects what we see, evens out contrasts, and also includes all surrounding circumstances including our own feelings. It is a well-known phenomenon that the image captured on the sensor or film does not always match the actual event. This becomes quite clear when you try to explain the poetry of the moment with a vacation snapshot. Therefore, the key is not only to influence the quantity of light, but also the quality.

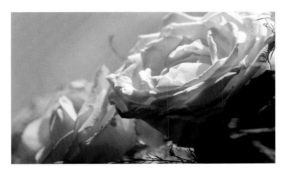

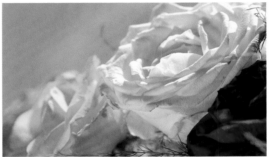

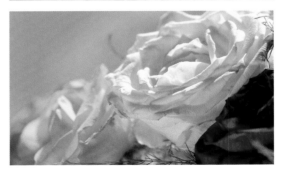

*Top: With existing lighting, the camera reproduces the shadows much harsher than the human eye perceives them.*

*Middle: Silver reflector adds light to the shadows, thus the shadow detail is much more visible.*

*Bottom: Gold reflector adds light to the shadows. Now the color of the light matches the object, and the mood seems as sunny and bright as the original.*

Although "normal daylight" is a valid term, it includes many differing modes of lighting conditions. Daylight can vary from harsh, bright sunlight; to reduced, soft lighting conditions on a cloudy day; to dull, gray light on a rainy day.

Ideal daylight conditions for closeup photography are found on slightly overcast days without direct sunshine. An overcast sky has the effect of a huge softbox and gives unsurpassed soft light. Delicate, fine structures of plants are preserved, while detail is shown in both the highlights and shadows. Direct sunlight is a lot more problematic. Notably, with respect to the use of digital cameras, direct sunlight is likely to cause shadows to block up or highlights to burn out. There are two options to deal with this lighting situation. If the overall lighting level or contrast should be toned down, you can soften the sunlight with a diffuser. With small objects you can even use a piece of transparent tracing paper. If you want to keep the mood of sunlight, you can brighten the shadows with a reflector. Depending upon the surface color of the reflector, you can add warm (gold reflector) or neutral light (white or silver reflector). You can also achieve interesting effects with colored reflectors. In closeup photography a common

method is to utilize the aperture priority mode. The desired aperture is set manually and the camera determines the necessary shutter speed through the internal light meter. In normal situations the light meter will give you the correct exposure, but there are circumstances in which you will have to make corrections. If you want to photograph snow or ice crystals, for example, the camera interprets the evenly bright surface as middle gray and underexposes. You must intentionally overexpose to achieve the correct exposure. Dark objects or dark surfaces are different; now you must shorten the automatic exposure to correctly expose the object. However, since a correct exposure does not always create the desired mood in a picture, be sure to take several shots using various exposures (called bracketing) under critical lighting situations.

Daylight can have very different qualities, all of which can be used to create your pictures.

Left: Direct sunlight with hard shadows, high contrast, and intense colors.

Middle: An overcast sky almost completely eliminates the shadows; fine structures are preserved.

Right: With evening light, the setting sun brings a moody atmosphere.

Backlight (light falling directly into the lens) causes an effect in which the subject in the foreground will be reproduced very dark, and in extreme cases as a black silhouette. Spot metering of the most important image detail, and saving the measured value, gives you the correct exposure. If it is not possible to find a suitable area for spot metering, you can take a camera meter reading off a gray card (or in a crunch, you can use the palm of your hand), then manually set the exposure on the camera. Of course, you can also use a reflector or a fill-in flash to get good results in backlit situations, but the lighting mood of the image will change. The result you like best depends on your taste and what the picture is supposed to say. The correct handling of light is an important step in the development of your own personal expression.

▲ If the object consists mostly of bright areas, you must purposefully overexpose; in this case +1 stop.

▲ In this backlit situation, the correct exposure was determined by means of a spot meter reading of the dark areas on the stem.

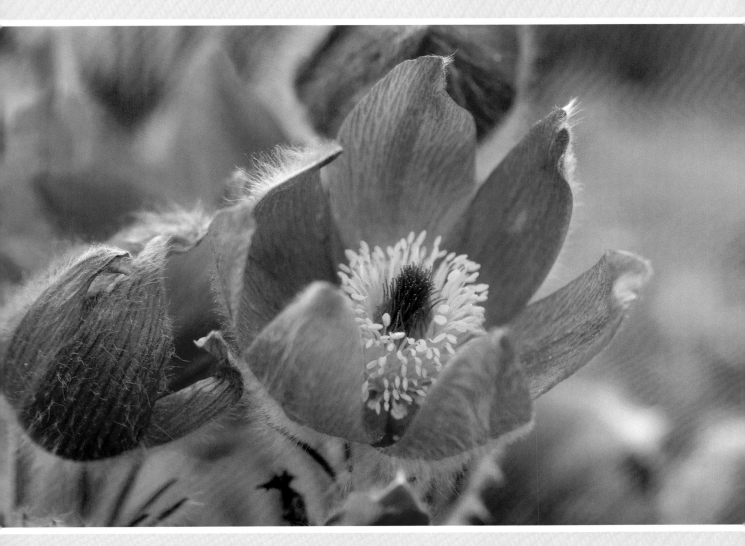

▲ *Pasque flower. 1/500 sec at f/4; 150mm macro lens. A slightly overcast sky is ideal for closeup photography; the low contrast prevents problems with light metering, and the light intensity is strong enough to hand-hold the camera even at a longer focal length.*

# Artificial Light

Continuous (non-flash) light sources have the great advantage of allowing you to see what you are doing while setting up the shot, which is especially important for beginners. This can be helpful even in tabletop photography, enablling the lighting situation to be readily evaluated through the viewfinder while lighting complex scenes. The vast array of available artificial light sources makes it difficult to find a single solution this is equally suited for all imaging situations.

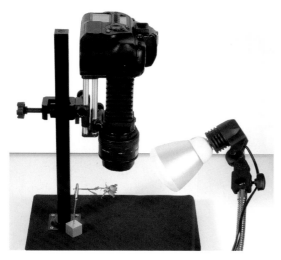

▲ *Daylight lamps are especially useful for static objects. A great advantage is that they do not develop much heat. Keep in mind that they do not perfectly correspond to natural daylight.*

A frequent problem is the differing color temperature of individual lamps. As soon as another source of light is added (e.g., daylight), you will see undesirable color-casts. This is unavoidable, even when using a conversion filter in front of the lens, or by correcting the white balance. The only solution is to filter the light itself. Appropriate colored foils can be bought at professional camera stores, but they will not deliver a 100% correction. Sometimes, it can be fun to use this color difference of the lights creatively.

### Incandescent and Halogen Lights

Incandescent and halogen lights emit a very bright light, which allows for relatively short shutter speeds at small apertures. Both types of lights have the disadvantage of developing a lot of heat, and thus are not suitable for many sensitive subjects. The color temperature is approximately 3200 Kelvin (for incandescent lights) and 3400 Kelvin (for halogen). In both cases (if unfiltered), they will produce a yellow cast in your image.

### Fluorescent Lights

Fluorescent lights are available in different color temperatures. The most common type, labeled "neu-

tral white", is approximately 4000 Kelvin. A special adapter is needed to eliminate flicker from the light, otherwise color stripes may show in your image at some shutter speeds.

## Daylight Lamps & Tubes

Daylight lamps and tubes are similar to fluorescent lights, except that their color temperature lies at approximately 5000 Kelvin. The biggest advantage of all fluorescent lights is low heat radiation. Therefore, they are well-suited for closeup photography, and are appropriate for tabletop projects when used as a flat-panel flash.

## LED Lights

LED lights are energy efficient, but in order to reach an acceptable output of light they must be used in large quantities. They come specially made for closeup photography in the form of a ring light (other forms are not yet available). Hopefully, changes in this area will be seen in the future. The low energy usage means LEDs are ideal for traveling. With a little know-how, it is not difficult to build one yourself.

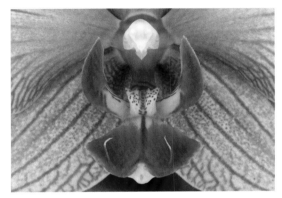

▲ *Orchid flower; detail. 50mm macro; 1/8 sec at f/32; ring flash with fluorescent light tube.*

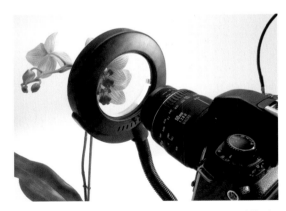

▲ *A round fluorescent tube attached to a modified magnifying glass lamp (without the glass) leads to an even, shadowless lighting.*

# Flash Lighting

For good reason, flash lighting has become a universal light in photography. No other type of lighting has such an intensive light output, occupies such a small space, and is completely independent from an electrical network. A flash is more than simply an aid to supply missing brightness. Some lighting effects can only be achieved with a flash unit. Freezing of movements with ultra short light bursts, synchronization with the rear curtain, stroboscope flash, and others, give the photographer many possibilities to create images according to his imagination. Unfortunately, there is a disadvantage to flash lighting. With the common compact flash units, as opposed to the professional studio strobes, it is not possible to work with a modeling light to evaluate the effect of the lighting prior to taking the picture.

*Even the addition of a small hot-shoe flash attached to a bracket allows for more creative lighting options compared to the internal flash of the camera.*

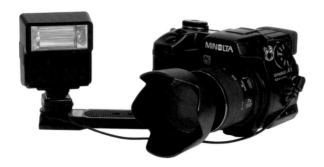

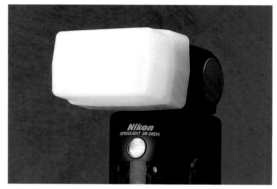

▲ *With a diffusion screen, the light from the flash becomes a little softer. Photograph: Tom Lense*

With a digital camera you can compensate for this by taking a few test shots. Thus, it is worth looking into the opportunities that flash lighting offers to closeup photography.

The capabilities of a built-in flash are rather limited. The degree of illumination rarely lights objects completely, even at short working distances. To make matters worse, the lens may sometimes interfere with the direction of light causing part of the picture to be cast in shadow. This is one reason why many compact and bridge camera models automatically turn off the built-in flash when in macro mode. An off-camera flash offers you many more options, and

an inexpensive flash bracket for off-camera use can be purchased in a camera store. A prerequisite for the use of an off-camera flash is the outlet for a sync cord on the camera body, or alternatively, a camera equipped with a standard hot shoe for which an adapter with internal sync cord exists. Now you can control where the shadows fall by changing the position of the flash. Still, the intense character of flash lighting renders a very harsh light. To soften the illumination, you must increase the size of the light source. The easiest way to achieve this is by using a small reflector flap (see building instructions on page 127), in which case the light is bounced off the reflector indirectly lighting the object. An even softer light can be created with a flat-panel flash or a softbox; even a small version shows more detail in the shadows and background, and creates a more even lighting to the scene. Light reflections on shiny surface areas (e.g., water drops) have a more attractive shine to them and look more three-dimensional. Several off-camera flash units used together give a professional studio feeling. The ability to direct light onto the object from multiple directions combined with through-the-lens (TTL)-metering can conquer even complex lighting situations without much trouble. This offers significantly more creative

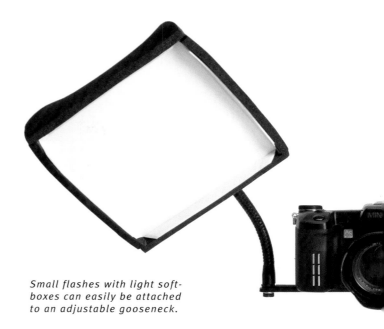

*Small flashes with light soft-boxes can easily be attached to an adjustable gooseneck.*

*As an alternative to a softbox, a flat-panel flash can be used. The simpler models do not come with TTL metering, but the results are still respectable.*

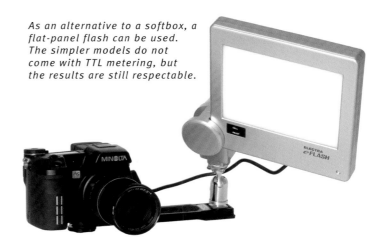

options than that of a single compact flash, which can only be used in manual or auto mode. Whether you choose the simple or the professional solution depends not only on your budget, but also on how the equipment will be used, and the kind of pictures you strive for. You certainly do not need the latest technical gadgets. Even if they are sometimes of help, creativity and the ingenuity with which you use technology in creating your images is much more important.

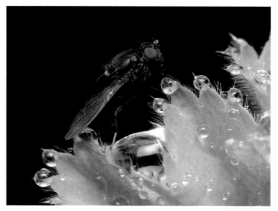

▲ *Fly in garden. 1/60 sec at f/11; ISO 400; 105 mm macro lens; TTL-flash with softbox. You can clearly see the reflections of the softbox, which allow the water drops to look 3-dimensional.*

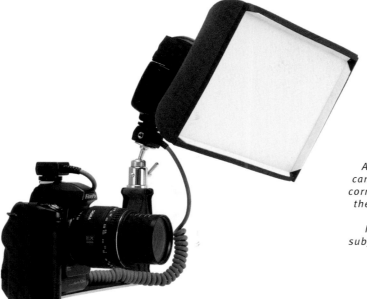

*An off-camera flash with softbox can still be used with TTL with the correct sync cord. Softboxes model the light much softer. They do not even have to be very large. In comparison to the size of the subjects in closeup photography, a lighting area of 20 x 30 cm (8 x 12 in) is huge.*

Some flash units have been specifically developed for closeup photography. You can find ring flash units, duo-flashes, and wireless solutions with individual flash units controlled by infrared. They have in common an extraordinary mobility and ease of handling due to the flash module being attached near the front of the lens. There are great differences in the light quality in these various types of flash units.

If you are considering the purchase of a ring flash, you should choose one with at least two separate flash tubes that can be controlled individually. The light of the simpler models with only one flash tube is almost shadow-less, but is therefore also flat, and almost boring. If necessary, you can make adjustments to the light by taping a piece of gray filter foil on to parts of the flash. Ring flash units are particularly suited for use in the area of technical and scientific documentation, in which the visibility of all details is important. Their light even reaches into areas that would be cast in deep shadow by normal flash units. However, shiny surfaces may show the form of the ring flash reflected off the object.

Duo-flash units have flash heads that can be tilted or swiveled individually, offering the option to illuminate the background separately from the main object. One head can be used as a main light for the object,

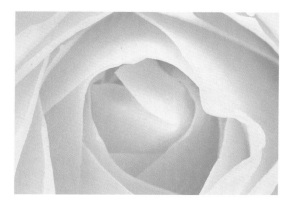

▲ *Detail of a rose. The uniform lighting reaches otherwise inaccessible areas that would be cast in shadow with other types of lighting.*

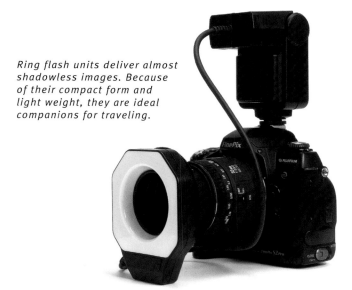

*Ring flash units deliver almost shadowless images. Because of their compact form and light weight, they are ideal companions for traveling.*

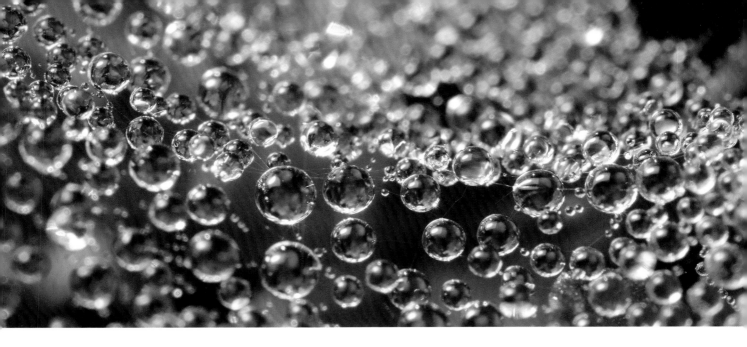

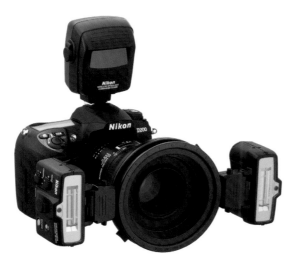

while the other one is used to fill in the shadows. Most units offer diffusers as accessories which can soften the lighting.

A wireless infrared remote control currently offers the greatest flexibility in flash photography. Besides the individual flash heads additional external flash units may be added to the system and can be controlled separately. Assuming compatibility with your camera, you can construct a lighting system which hardly leaves a wish unfulfilled.

## Overview of Closeup Lighting

Legend:
- **+** perfect
- **●** well suited
- **○** limited use
- **✕** not suitable

| Daylight, Sun | Daylight, Overcast | Sunrise / sunset, light streaks | Internal camera flash | Hot-shoe system flash | Ring Flash | Duo-flash, controlled individually | Off-Camera Flash | Off-Camera Flash with Softbox | Several Off-Camera Flash Units | Studio Strobes with Modeling Light | Artificial Light, Incandescent, Halogen | Artificial Light, Cold Light Lamps | Artificial Light, Ring Light Neon | Light Tent with simple Compact Flash | |
|---|---|---|---|---|---|---|---|---|---|---|---|---|---|---|---|
| + | + | + | ● | + | + | + | + | + | + | + | ● | + | + | + | Up to magnification 1:2 |
| + | + | + | ○ | ○ | + | + | + | + | + | + | ● | + | + | + | Up to magnification 1:1 |
| ○ | ○ | ○ | ✕ | ✕ | + | + | + | + | + | + | ● | + | + | ● | Up to magnification 2:1 and beyond |
| + | ● | ○ | ○ | + | + | + | + | + | + | ○ | ✕ | ✕ | ✕ | ✕ | Smaller animals/insects (active) |
| + | + | + | ● | + | + | + | + | + | + | ● | ✕ | ○ | ○ | ○ | Smaller animals/insects (passive) |
| ● | + | + | ○ | ● | + | + | + | + | + | ✕ | ✕ | ✕ | ✕ | ○ | Plants / Flowers in Nature |
| ○ | ○ | ○ | ○ | ● | + | + | + | + | + | + | ● | + | + | + | Plants / Flowers in the Studio |
| ○ | ○ | ○ | ○ | ● | + | + | + | + | + | + | ● | + | + | + | Technical / Jewelry / Collections |
| ● | ○ | ✕ | ○ | + | + | + | + | + | + | + | ● | + | + | + | Highest Depth of Field |
| + | + | + | + | ● | ○ | ○ | ● | ● | ○ | ✕ | + | + | + | + | Limited Budget |

All statements are made solely to help orient the reader. Depending upon the type of object, requirements, and prices, these suggestions can change slightly.

▲ *Bumblebee. 1/180 sec at f/5.6; 90mm macro lens with 2x teleconverter; tripod.*

*An overcast sky creates an unsurpassable soft light that evenly lights the object and the background.*

▲ *Bee on flower. 1/125 sec at f/11;*
*50mm macro lens; duo-flash with*
*softboxes; handheld.*

*Due to the short range of the flash,*
*a distant background will appear*
*almost completely black. This will*
*clearly separate the object from the*
*background.*

# Controlling Flash

There are several options to trigger one or more flash units. The simplest option is to use a sync cord, however, this limits you to using the manual control or the auto function of the flash unit. Control via a TTL-sync cord is more comfortable. This gives you the ability to use most functions of the system flash off-camera. A disadvantage of both options is the cable itself. As long as you connect the flash to a flash bracket (mounted on the camera) the cord does not pose much of a problem. A wireless solution can be suitable for use with one or more flash units that would otherwise be constrained by the maximum length of a sync cord or TTL-sync cord. There are also a few various options for wireless controls. They run the gamut from the simple infrared transmitter and receiver to the complete TTL-controlled wireless solution in which all relevant information is transferred by means of a pre-flash or infrared flash. Both these methods require the camera and flash units to be in sight of each other, which is usually the case in closeup photography. However, bright sunlight may limit the functionality of the slave and/or the receiving units.

The radio transmitters (originally developed for studio strobe lighting units) trigger the flash even if an object is situated between the camera and the flash. In addition, they offer the longest range between the camera and the flash unit. With careful planning (and with some experience) the fact that they can be used only in manual mode or with the auto function of the flash units is not much of a disadvantage. To add a radio transmitter to the system flash you will need an additional adapter on the PC cord plug of the camera.

▲ *System flash via TTL cord: With a distributor you can control more than one flash unit with TTL.*

▲ Infrared transmitter: The flash signal is transferred using an infrared light not visible to the camera.

▲ Slave unit: The slave triggers the off-camera flash by receiving either an infrared signal or a normal flash.

▲ Radio transmitter: The signal is transmitted by radio signal on one or more channels.

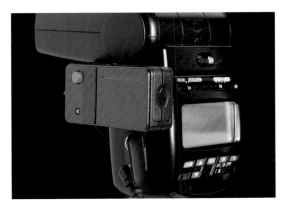

▲ Radio receiver: Developed for studio strobe systems; it can be used on system flash units with an adapter.

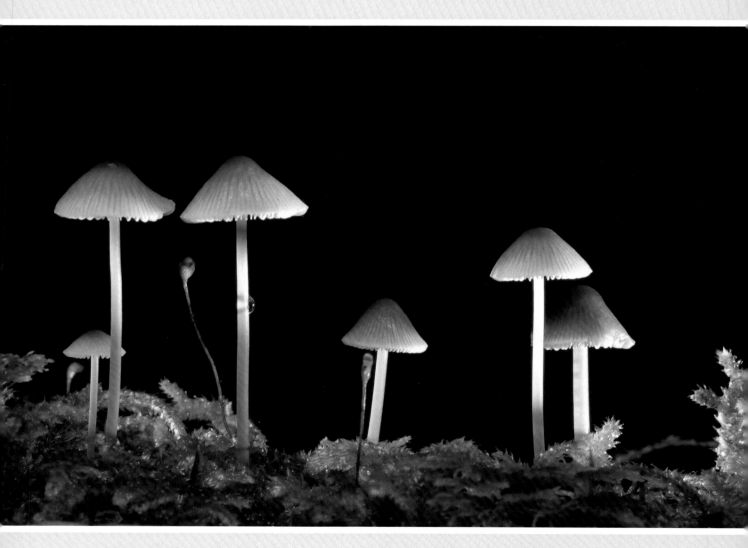

▲ Mushrooms on moss-covered tree
trunk. 1/60 sec at f/16; 50mm macro
lens; flash with softbox from the front;
small slave flash for lighting effect.

Placed on the right, behind the tree
trunk, the slave flash unit lightens up
the "floor lamps".

# Flash Lighting Used Creatively

Whether shooting indoors or outdoors, with the use of several flash units, moody lighting situations that help display the essence of your object can be created. While walking through the woods, I once discovered a small grouping of mushrooms on a moss-covered tree trunk, which at first sight reminded me of floor lamps commonly used in home décor. I quickly set up a tabletop tripod with a DSLR camera and a 50mm macro lens. I used a cable release to avoid camera shake. With the existing diffused daylight I was able to capture a nice image, but the "floor lamp" effect I had in mind was not quite conveyed. For the second photograph, I lit the scene using a system flash unit with softbox directly from the front. This created an even lighting of the mushrooms without distracting reflections, and above all, rendered the background dark (as I had envisioned it). However, I achieved the desired effect only by adding a second flash unit, placed on the right hand side behind the tree trunk and triggered by a slave unit. The mushroom "lamps" were finally lit up.

▲ *Without flash the background becomes part of the image. 1/8 sec at f/9.5; 50mm macro lens; tripod; cable release.*

▲ *Using flash from the front only, the background becomes almost completely black since it is a few meters in distance*

▲ *Lichen on tree bark. Original size approximately 5 x 8 mm; 1/125 sec at f/22; 90 mm macro lens with bellows;* *flash with softbox. The picture shows the lichen in a documentary image with all details.*

▲ Lichen on a fork of a branch.
1/180 sec at f/5.6; 50mm macro
lens; monopod. Because of the
large aperture, the background becomes
blurred. Together with the monochrome
colors a moody image is created.

# Closeup Paradise in the Meadow

An afternoon in a flowering summer meadow with a camera and closeup lens is paradise on earth for most closeup photographers. In a relatively small area, you can discover an amazing number of subjects. On the top level, flowers and flying insects dominate the scene. Insects, bumblebees, and/or butterflies are constantly in motion and searching for food, and thus can be difficult to capture on film or digital medium. You need to be calm and patient. Limit yourself to a small sector of picturesque flowers and wait for the "guests" to arrive; this is much more successful than chasing after the insects, resulting in scaring them away. The wait can be used to clean up the scene a bit, e.g., carefully pulling distracting stalks out of the way.

By diving under the surface, you can discover new and interesting insights into the world of its inhabitants at every level. Here lies the kingdom of beetles, grasshoppers, spiders, caterpillars, snails, etc. Since most of these creatures are sensitive to vibrations, it is advisable to move carefully and quietly in these areas. A right-angle viewfinder or LCD displays that can be tilted or swiveled are very useful in setting up your shot from an unusual perspective, and in addition, they will save your back when working close to the ground. The best time to find subjects is shortly after a rainstorm or when the early morning dew and the warming rays of the sun bring life back to the world of insects. At these times, many plants (and especially spider webs) are covered with glittering dewdrops, which can restrict some inhabitants of the meadow from traveling around. Remember to bring a water resistant mat to prevent wet knees and grass stains while taking pictures at ground level.

▲ *For closeup photography you need some luck, but above all, have your camera readily available.*

▲ *Pieris brassicae. 1/180 sec at f/8;*
*ISO 200; 150mm macro lens.*
*Many animals will return to the same*
*location if they feel safe. Much*
*patience and perhaps pre-focusing*
*on especially picturesque areas will*
*give you greater odds of capturing*
*them with your camera, rather than*
*chasing them around and possibly*
*scaring them away.*

# Strategies for Sharp Images

You will not always be able to produce sharp images without motion blur. However, if you pay attention to some basic considerations, you are likely to produce good results.

## Blurring

The origin of blurry pictures is primarily derived from shutter speeds which are too long. This can easily be solved. A larger aperture automatically gives you a faster shutter speed, but a large aperture opening also comes with a shallow depth of field that is not always desired. If the aperture needs to stay the same (i.e., smaller/slower), the following may be used: a tripod, a higher ISO value, a film that is more light sensitive, and/or an image stabilizer. A rule of thumb is that the shutter speed as a number should not be lower than the focal length of the lens. For example, this means that with a 50mm lens you have a good chance to achieve a sharp image at 1/60 of a second or faster. However, when photographing in the closeup range, the possibility of blur is much higher. Therefore, you should choose the next higher shutter speed as the minimum shutter speed. With a 50mm macro lens, you should select 1/90 or even 1/125 sec. Owners of DSLR cameras also have to consider the focal length multiplication factor. Another reason for blurry images can be due to the shutter lag of the camera. Especially after switching from analog to digital, you may have to get used to the shutter lag inherent in some compact digital cameras. (Shutter lag on DSLR cameras is hardly detectable, and is further reduced on high-end consumer models.)

## Out of Focus While Using a Tripod

Even when you are working with a tripod, some images may come out blurry. This can be due to the vibration the mirror generates when it is flipped up on SLR cameras. The solution is to lock up the mirror prior to the exposure, but not all camera models offer this feature. In addition, it is best to always use a cable release or an infrared transmitter. If none of these options are present, use the self-timer on the camera. Another mishap resulting in blurry images can occur during focusing. While looking through the viewfinder, you may inadvertently move the camera slightly forward, then, after you move away from it, the camera returns to its original position. The result: the focal point is positioned in front of the object. Due to the very shallow depth of field in the closeup range even 1/10 of a millimeter

can be enough to make the image appear out of focus. If you go beyond a magnification ratio of 1:1 it is suggested not to focus with the lens at all, but to mount the camera on a focusing rail to achieve much finer adjustments.

## Motion Blur

If the shutter speeds are too long and the subject moves during the exposure (e.g., because of wind) this will lead to blurred images. Here, the only remedy is to use very short shutter speeds or one or more flash units to freeze the motion.

## Incorrect Focal Point

The exact focusing of closeup images is often difficult to achieve, especially with a handheld camera. Because your body tends to slightly sway forward and backward, the exact focal point is hard to pinpoint. A more stable body position can be learned. Avoid a bent position; it is best to sit on the ground and brace your elbows on your knees.

## Handheld Closeup Photography

In many cases, it may be difficult or impossible to set up a tripod and arrange your composition and lighting before taking a picture – that is when you have to shoot handheld. The classic solution of working with a flash allows you to work with small apertures even in poor lighting conditions, and thus allows you to reach the largest possible depth of field. If the use of flash is not allowed or not desirable for the arrangement, you can attain faster shutter speeds by changing the value of the ISO setting (e.g., to 800-1600), which permits you to sharply capture even moving subjects. There is a certain loss of quality that must be accepted though, due to the higher levels of image grain/noise. Image stabilizers are becoming more frequently available with modern cameras and lenses, and allow you to use much longer shutter speeds. They are only useful for motionless subjects though, since they equalize the motion of the camera, not the subject. Despite this, they can be a great help in closeup photography when you are hovering on the edge of those exposure times that may still be handheld.

▲ Heliconius hecale. 1/20 sec at f/3.5;
ISO 100; 28mm digital bridge camera.
Thanks to an image stabilizer you may
still be able to take pictures without
a tripod even under poor lighting
conditions. Of course, a motionless
subject is still required.
Photograph: Tabea Harnischmacher

▲ Dryjas Julia. 1/500 sec at f/4.8;
150mm macro lens; ISO 800.
If the subject is in motion and you
cannot or do not want to use flash,
the only alternative is to use a high
ISO value so you can use very short
shutter speeds.

▲ 1/125 sec at f/4; 150mm macro lens; ISO 1600. This photograph was only possible because of the large aperture and the high ISO value. The result is an extremely shallow depth of field that can be used creatively in the composition.

▲ 1/60 sec at f/9.5; 150mm macro lens; ISO 200. To reach an acceptable depth of field in this portrait, a flash with softbox was used.

All pictures in these examples were taken at the butterfly house on the island of Mainau.

# During All Seasons

In spring, the high season for closeup photography begins. Suddenly, you are surrounded by the sight of flowers and the hum of insects as nature stirs again after the long pause of winter. Butterflies and dragonflies are often favorite closeup subjects, in addition to a myriad of other insects. It helps enormously to have some background knowledge of your intended subject's life habits in order to capture the desired shot. You can find butterflies such as Danaus plexippus (the Monarch butterfly), laying their eggs on milkweed in the spring, or Nymphalis antiopa (the Mourning Cloak butterfly) feeding on oak sap in the summer. Dragonflies can be found between May and August mostly near lakes, calm rivers, and creek beds. Some dragonflies will repeatedly return to the same exposed resting place from which they can overlook their territory. Observing their behavior while searching for the right camera vantage point can be a great benefit. A tip for early birds: if you photograph shortly after sunrise, many insects are not as active in the early morning as they are later in the day, and can be captured with your camera more easily.

Of course, having your own garden is ideal for intensely occupying yourself with closeup photography. It is quick and easy to find the necessary tranquility, and it gives you the option to leave your camera set up on a tripod for an extended period of time. With your camera pre-focused on a particular flower (infrared remote control in hand), you can now wait for your guests ("the models") from a safe distance. If you have the opportunity to allow part of your garden to return to its natural, wild state, use this to your advantage. You will be rewarded with a multitude of fascinating subjects. Even if you live in the middle of a city, you can create a small closeup paradise with a handful of seeds, a few flowerpots, and your imagination. This will allow you to take many fascinating photos during the course of the different seasons. Time-lapse exposures of opening flowers and variations of different lighting situations are as much a part of this topic as are images showing closeup details of the subject.

Some annual occurrences, such as the blossoming of trees, are especially suited for more intensive work on one subject. Your summer vacation in the mountains or at the sea gives you the opportunity to assemble a photographic, closeup travel diary about the flora and fauna of the vacation region as opposed to common holiday pictures.

In fall, the mushroom season begins -- a good time to look for subjects from a photographic perspective. Countless objects literally arise from the ground overnight and can be transformed into impressive scenes through the use of numerous lighting techniques. Even in dim lighting situations, the use of direct flash should be avoided whenever possible while photographing mushrooms. Reflections on the shiny surfaces can be avoided with a softbox, or by using an indirect flash with a reflector. Also, back lighting or long exposures using a flashlight as a light brush can show off mushrooms in an especially appealing light. Moss, lichen, grasses, and wilted foliage in every imaginable shade of yellow, green, red, and brown can be wonderful subjects for still lifes, as well as for light and shadow studies. Even in the rain, you can find many interesting subjects. At these times, you should carefully protect your camera equipment from moisture, e.g., with an underwater housing. It can be worthwhile to get out early when the nighttime temperatures first drop to freezing, and frost covers the pastures and meadows. In the early morning light, the finely detailed filigree structures of ice and snow crystals are most pronounced and have not yet begun to melt. A visit to an icy waterfall can be a special photographic experience. Besides a telephoto lens and a tripod, it is recommended to take a pair of crampons that can be attached to your shoes. Due to the constant water spray, the surrounding areas may be covered in a blanket of ice, which is quite photogenic, but can be very slippery. With long exposures, you can produce nice contrasts between the flowing water and static icicles. If it is gray and gloomy outside for weeks on end, go for a visit to the greenhouses at your local botanical gardens.

Another opportunity to creatively use the winter season is to buy yourself (or your sweetheart) a bouquet of flowers and practice refining your imaging techniques, directing of light, and composition right in your own home.

*A small hand warmer is effective in the winter because the small buttons and elements of modern cameras are hard to handle with gloves.*

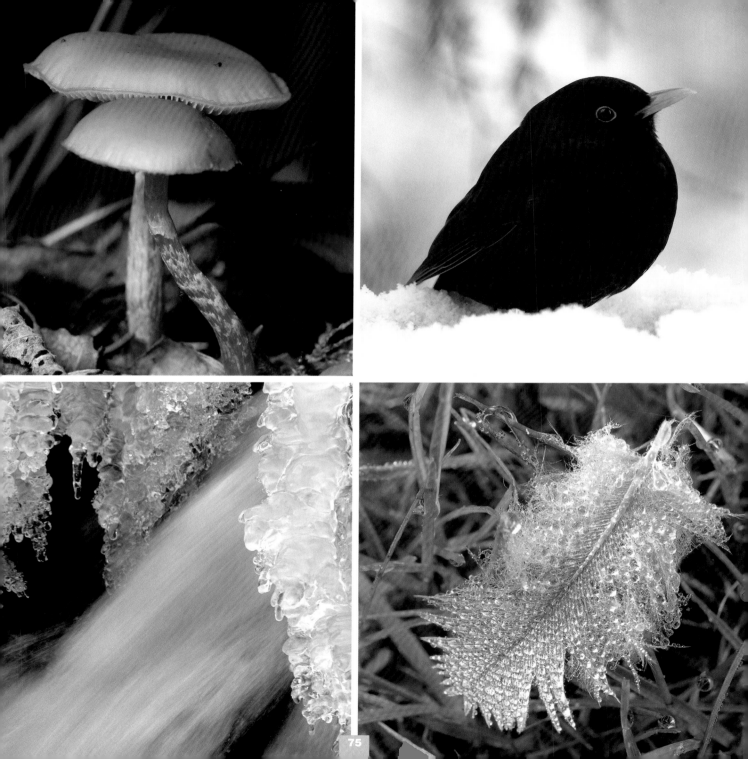

# Travel Closeup Photography

Photographic travel trips can be special adventures. Free of time pressures and every day stresses, you can solely focus on the subject of closeup photography. Interesting travel destinations could be the national parks or wilderness areas in the U.S., as well as distant, exotic countries. Besides the forests and meadows near your front door, interesting photographic travel destinations such as zoological gardens, wild animal and bird parks, butterfly habitats, and special flower shows can be found.

However, some of these places may permit only limited photography, therefore, you should determine this information before you go, and also find out if there are any restrictions on the use your images. In most cases, the non-commercial use of your images is permitted. If you are out in nature and want to photograph specific plants or animals, it is especially helpful to learn from the experiences of others. Those who like to combine theory and practice should look into closeup photography workshops. Of course, the respectful treatment of nature is always encouraged.

## Know Your Subject

You can go on a spontaneous photo outing, but you may walk past many exciting photo opportunities without even noticing. It is extremely beneficial to know at which time of day or year certain flowers bloom, and the behavior patterns of particular insects and animals which you plan to photograph. Through time spent in research prior to your photographic expeditions, you will be rewarded with in an increased number of quality images. For example, if

*You can collect quite a bit of weight while packing for a photo trip. Here, one camera body, two lenses, and a few accessories weigh more than 13 lbs.*

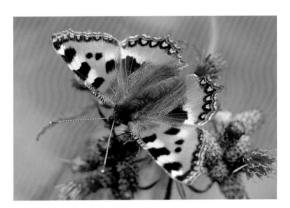

▲ *If you know the flowering time of food plants for certain animals, you can prepare your trip accordingly. Thus, it is practical to check out a good reference book on the subject.*

## Closeup Photography On the Road

The ever-growing use of digital compact and bridge cameras has had an effect on the quantity and type of equipment used. Today, a single camera can feature the equivalent of a whole series of lenses (including an extreme telephoto lens), an image stabilizer, and closeup function. The problem of carrying around a large supply of equipment applies only to owners of SLR cameras. The weight and bulk of the equipment itself is not the only issue, however; with the use of electronics in modern photography an appropriate energy source must also be available, therefore a supply of batteries may be necessary. This certainly does not help mobility. The understandable need to

you are searching for a specific kind of butterfly, you should proceed systematically and first look for the appropriate food plant. Taking a look into a good reference book is more than just satisfying a naturalistic or biological interest; when armed with the knowledge of an animal's food and habitat range, your chances of locating an elusive subject are highly increased. Last but not least, choosing the right lens depends upon the expected subject. With the use of a telephoto lens, shy animals may be observed without scaring them away. It is important to be as quiet as possible while preparing your camera and setting up your tripod.

▲ *Interesting macro subjects can be found just about anywhere, even though they are sometimes quite hidden.*

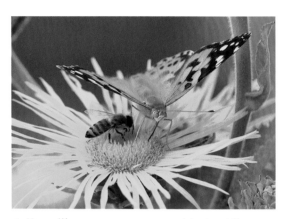

▲ *You will come across many subjects while taking a walk during the summer. If you want to react quickly, the camera should be kept handy, e.g., in a fanny pack.*

pack all the available lenses so no image situation will be missed often leads to the problem that the photo bags will be very heavy. Do without unnecessary ballast and limit yourself to one or two good lenses, a flash, a tripod, enough rechargeable batteries, and a few accessories (such as an infrared remote control). All this should fit nicely into a medium sized, well-padded photo backpack. Taking along more than this limits mobility and hinders the ability to work in a relaxed manner. If you can manage with just your small equipment, a fanny pack is an

even better option. With a fanny pack, the camera can be easily reached without the need to take off a backpack. Due to the potential contamination of a DSLR's sensor, when traveling in extremely moist or dusty regions, you may want to consider using an older SLR camera that can be adjusted completely manually and a few rolls of good slide film as an alternative.

**Safety Considerations**

Personal safety is of utmost importance; protect yourself against accidents and illness. If you are searching for your subjects predominantly in the forest and meadows, you should think about protection from ticks, and possibly consult your family doctor. He can tell you if immunization shots are necessary, and offer advice about a travel first aid kit. A medication for insect bites should be included, because even when approaching bees and wasps respectfully, sometimes a misunderstanding occurs and you may be stung.

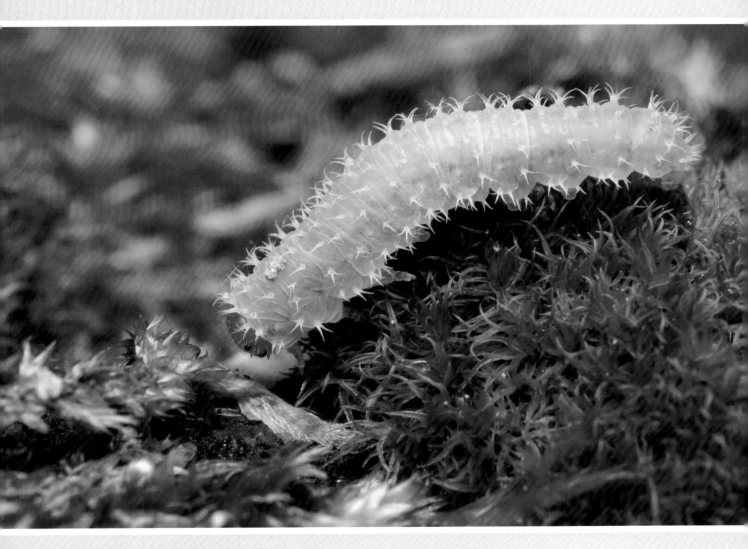

▲ *Rhogogaster viridis larva.*
*1/60 sec at f/13; 105mm macro*
*lens; flash with softbox; ISO 200.*

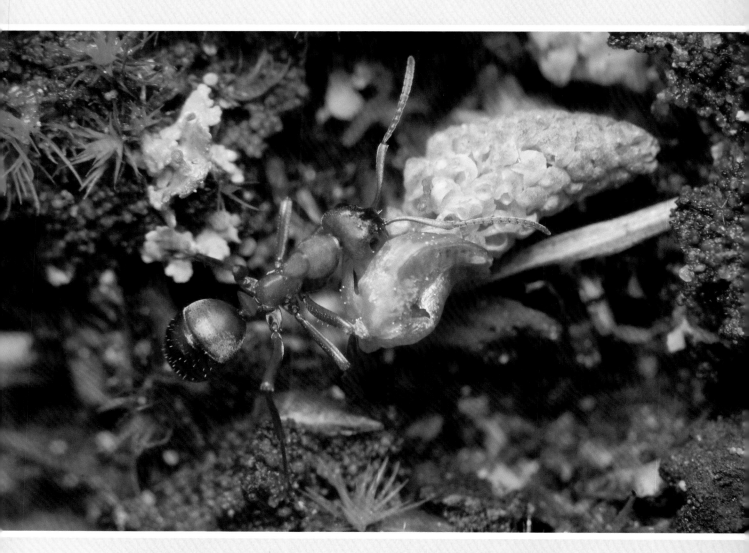

▲ *Red Forest Ant at Work. 1/60 sec at f/8; 150mm macro len; flash with soft-box; ISO 400. Because of the dim* *lighting situation at the forest floor, you cannot avoid using a flash (parti-cularly with active insects).*

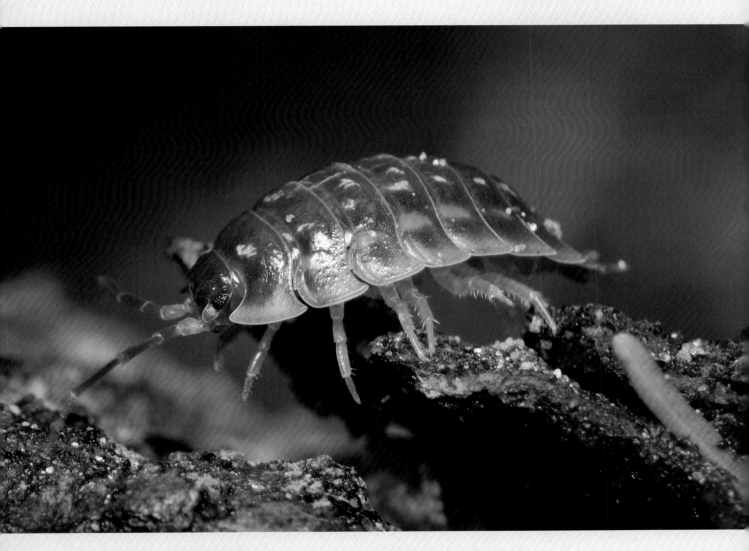

▲ *Isopod. 1/60 sec at f/9.5;*
*150mm macro lens; flash with*
*softbox; ISO 200.*
*The shiny shell of many insects*
*strongly reflects direct flash.*

*Undesirable reflections cannot*
*always be completely avoided, but*
*by using a softbox or indirect flash*
*on a reflector, reflections may be*
*minimized.*

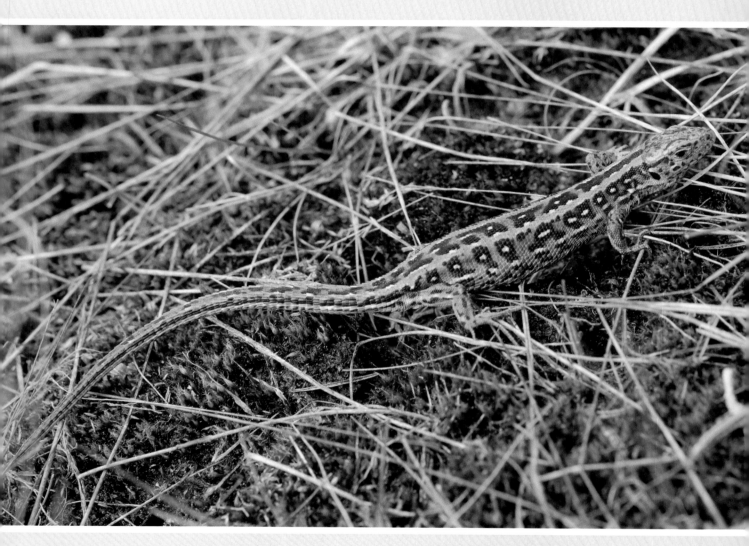

▲ Lizard. 1/180 sec at f/4.8;
105mm macro lens; ISO 400.
Many animals can only be
discovered by their movements.

When they flee, it is often too late to
capture a picture. Calmly moving
around in the natural environment is
a key to success.

If you plan on traveling to tropical or exotic locations, it is important to become informed about dangerous animals and plants. You will be moving around where nature is at home and you may be exposed to poisonous snakes and insects. Learning how to act accordingly can only be of benefit. The precautions you take are dependent upon your travel destination. The experience of others can be quite valuable. Become informed in a timely manner about the area's common illnesses, and get any necessary immunizations early enough. You can find information on the Centers for Disease Control and Prevention website at www.cdc.gov.

The safety of your equipment is also important. If you are the owner of an expensive camera and high quality lenses, you should consider purchasing special insurance for your equipment -- normal travel insurance will not cover a loss. If you are on the road for a period of time with a digital camera, you may also want to think about how to safeguard your data. It does not matter if you use a removable hard drive, a CD burner with rechargeable batteries, or a laptop computer to protect your data; in any case, it should be stored in two places. If you transfer the images from your flash card to a separate storage location, and then erase the flash card, you will not have protected your images, because your data still exists in only one place. If you are not too far out in the field, you can usually find a photography store or an Internet café where you can copy the contents of the flash cards onto 2 separate CDs; then mail one copy to your home, and keep the other CD in a safe place, separate from your camera and flash cards.

*To safeguard your photographs you can mail a copy of your images to your home while traveling.*

# Underwater Closeup Photography

The subject of underwater closeup photography could fill an entire book, since the water offers an inconceivable array of subjects for closeup photography. Until just a few years ago this field was accessible only to owners of highly priced specialty camera housings. In recent years, however, a few affordable alternatives have appeared on the market that may suit the amateur snorkeling enthusiast; these range from simple plastic diving bags to specialty polycarbonate housings custom-fitted to the particular camera. The need for a flash is inevitable since the intensity of light drops off significantly the deeper you dive. While snorkeling in shallow waters you can use natural daylight as a light source. However, even in water depths of only 1-2 meters your images will have a bluish cast to them due to the loss of red light rays, therefore your subject will not be rendered in its natural colors. For this reason, you should be careful when choosing your camera to ensure that the internal flash does not automatically turn off in the closeup mode. Before every use, carefully check to see that no debris or grains of sand have collected in the seals of the underwater housing. While diving, if you see air bubbles rising from the housing like a row of pearls, this is a sign of leakage and it may be too late to save your camera from water damage. Impressive underwater closeup images can be captured in zoos and aquariums. Most likely you will not be allowed to use flash, which will limit you to shooting still objects. Bringing your camera up close to the aquarium glass will eliminate the distortion of the glass from the focusing area, and thus, it will not affect your image. A large aperture allows you to separate incompatible backgrounds into a blur, as well as to use fast shutter speeds. It is best to photograph at a steep angle through the glass of the aquarium; a flat shot can influence the image quality considerably.

▲ *For closeup images in aquariums, you need high ISO values or very light sensitive films, since you are seldom allowed to use flash. The camera should be as close as possible to the glass to avoid reflections and distortion.*

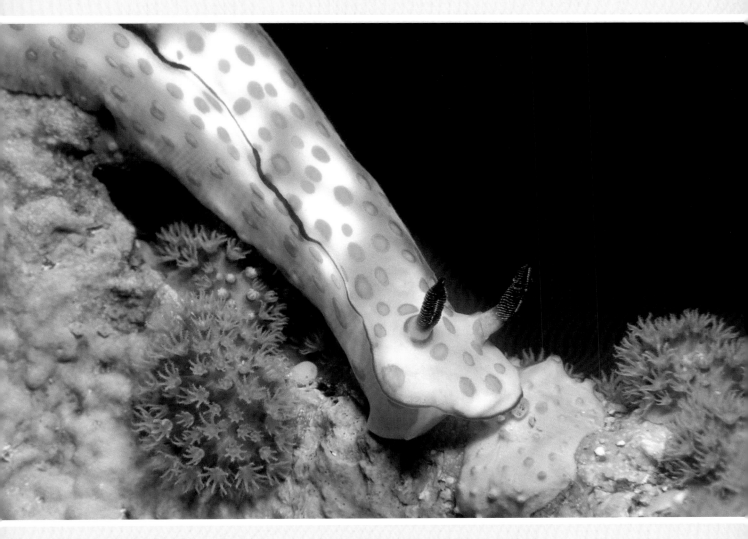

▲ *Partner-Risbecia, Red sea,*
*Elphinstone Reef. Analog SLR*
*camera with underwater housing;*

*1/60 sec at f/16; 105 mm macro lens;*
*flash.*
*Photograph: Kai Wallasch*

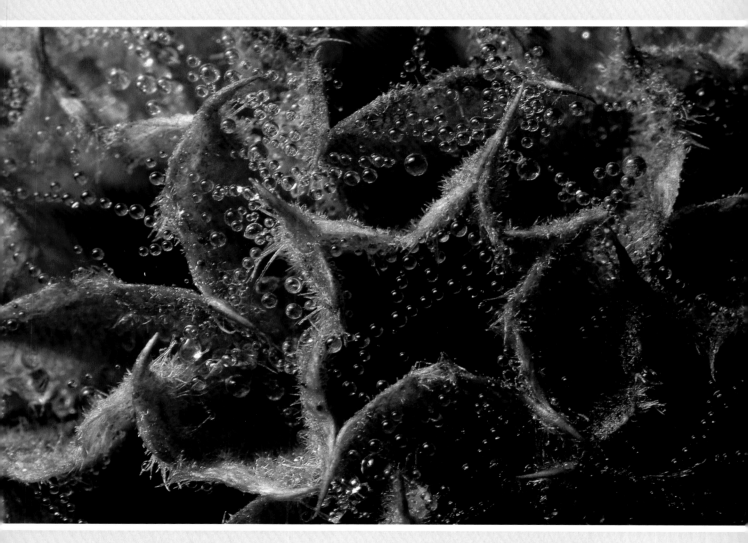

▲ *Dewdrops on wilted flower. 1/60 sec at f/11; 50mm macro lens;* *system flash with softbox; mounted to the left of the camera on a flash bracket.*

▲ *Romanesco Cabbage with*
*fractal structures. Studio image.*
*1/125 sec at f/22; 50mm macro*
*lens; tripod; system flash with soft-*
*box; black velvet background.*

# Tabletop Photography

Tabletop photography may also be referred to as "studio" or "still-life" photography. The appeal of tabletop photography derives from the idea that you can produce impressive pictures with simple means, therefore, the creative potential is very high. The financial investment and space requirements are modest, which should be appeal to beginners.

A small tabletop studio can be arranged in your living room. A table, two output-adjustable flash units, a few reflectors, and possibly a softbox for area-covering soft light are all the items you need in the beginning. More important than these tools is the creativity of the photographer and the ability to tell a story with the image. Prior to shooting the photograph you must come up with a plan. It is helpful to first draw a small sketch of the scene on which you can note initial ideas of how the light should be directed. The second step involves organizing props, as well as the background. You can find items at swap meets or while out hiking; little by little, you can gather a collection of decorative materials that may be used for subsequent pictures. Other places to search for materials are arts and crafts stores, or even thrift shops. Instead of the usual, solid colored backgrounds, you could use prints of photographs

(which, of course, should be your own). It is a good idea to plan ahead, and while hiking you can shoot interesting structures, cloud formations, and landscapes for your archives. With the play of sharpness and blur you can create backgrounds for the most versatile scenes. Once you have acquired all the necessary props, you can concern yourself with building the set and arranging the lighting.

Generally, less complex scenes need only one main light source and a few reflectors. A softbox generates a very soft light (see building instructions for the adaptation of a softbox for hot-shoe flash units on

▲ *With simple means you can adapt a strobe lighting softbox to fit a hot-shoe flash. Building instructions for the adapter can be found on pages 128/129.*

▲ *Penalty Kick. 1/125 sec at f/2.8;*
*50mm macro lens; hot-shoe flash*
*with softbox; manual control; 1/16*
*output; triggered via radio trans-*
*mitter.*

*Because of the open aperture, the*
*background becomes blurry and the*
*image displays the impression of*
*great depth. In reality, the ball is*
*positioned only a few centimeters in*
*front of the goal.*

page 128/129). Complex lighting should be set up step-by-step, and the lighting patterns should be checked by means of test shots (ideally with a digital camera controlled through a laptop). You will find a few interesting imaging techniques in the back of this book. Intricate arrangements can take a few days of your time, including time for acquiring materials and setup. Thereafter, you can create impressive images that can rival those of professionals.

*Top: To eliminate reflections off the porcelain surface, black tape was placed on the bottom of the shiny metal piece which connects the cup and saucer.*

*Middle: The "coffee" consists of a black, shiny foil attached at a slight angle to convey the movement of the cup. To simulate the hot steam, a piece of a burning cigarette was dropped into the cup shortly before the image was taken. A small opening in the foil allowed the smoke to rise.*

*Bottom: The main light comes from a softbox located off to the side; a second flash with a red color reflective foil creates the red glow in the background.*

▲ *Coffee inspires your senses.*
*1/180 sec at f/8; 50mm macro*
*lens; hot-shoe flash with softbox;*
*manual control 1/2 output;*

*additional flash with color filter;*
*1/8 output; triggered with infrared*
*remote control.*

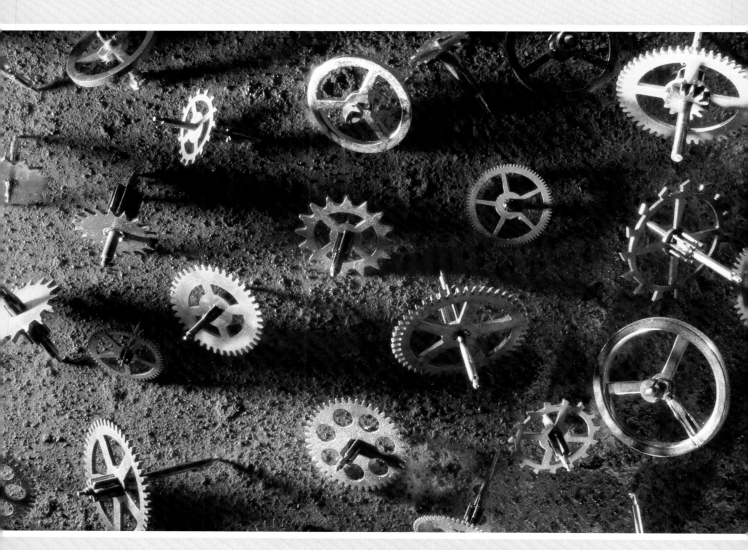

▲ *Cogwheels, studio image. 1/125 sec at f/27; 50mm macro lens; hot-shoe flash with manual control at 1/1 output.*

*The flash unit was positioned off to the left at the level of the cogwheels. In addition, several small mirrors were placed to redirect the light.*

# Product Shots

Whether for an Internet auction or a product catalog, the straightforward and factual rendering of products is a basic requirement for a successful sale. The concept should always come first, followed by a precise planning of the image. This is especially important when dealing with large numbers of similar objects that should be represented in a common theme. For example, if the pictures will be seen together in a catalog, you should ensure that all objects are shot with the same viewing angle and with the same direction of light. If you have to stop in the middle of a shoot, you should note all relevant adjustments on a sketch, such as position and focal length of lens, angle of tilt, distance to the product, etc. Thus, when you later return to your product shoot, you will not lose any time reproducing the correct set-up.

As basic equipment, a flash with a large softbox and a second, lower-output flash with a small softbox (to lighten up shadows) are all that is required for most situations. With curved cardboard for a seamless background, you can avoid distracting horizons in the background. In addition, you can lighten up the entire image by placing a white reflector above the scene. Small mirrors can function as a method to distribute light to specific areas and to redirect the

▲ *A translucent plastic bowl can easily be used as a simple closeup light tent, and is particularly suited for reflective and shiny objects.*

▲ *Lighting from one side only results in a soft, discreet shadow. Lighting from both sides gives a shadow-less illumination.*

light to desired target spots. Mirrors can imitate a true light source, when in actuality they are functionally reflected light. If the object will later be cropped out during image processing, you can place the mirrors and reflectors very close to the object to create effective light edges (emphasize the object's shape). At this point, using a flash system with a modeling light is an enormous advantage in evaluating the effect of the lighting. Ideally, the modeling light can be adjusted proportionally to the output of the flash. If your flash system does not have a modeling light available, you can check the image effect by means of several test shots. For a picture

that requires strict color control, you can add a color checker card into the shot, making it much easier to later correct the color on your computer monitor. To this end, you can either place the color-card into the part of the frame which lies outside the boundaries of the cropped image. Alternatively, you can place the card inside the image and take an extra picture that can later serve as a reference during image processing.

Shiny, concave objects have the distinct disadvantage of mirroring everything, meaning everything, including the photographer. The unwanted surrounding reflections can mostly be eliminated by use of a light

*Small umbrella reflectors are well suited for the mobile studio. They come coated in silver or gold, or may be translucent for a diffused lighting effect.*

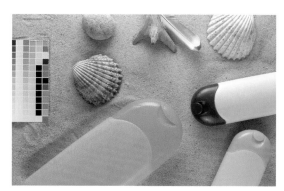

▲ *If correct color is important you can add a color checker card to the image outside of the planned crop.*

tent, but the problem with the photographer's reflection remains. There is a very simple solution for this. With a circle cutter make a hole in a black piece of cardboard equal to the size of the lens diameter. You can then take your shot through this hole without visible reflections of you and/or your camera. Together with the almost black front of your lens, the cardboard appears as an unnoticeable, continuous area on the object's shiny surface. Depending on how you cut the cardboard, you can influence the shape and size of the reflections. Presentation board from an art store with an internal foam core is best suited for this purpose. It is very lightweight, maintains its form, and is easy to cut.

An interesting effect may be achieved by placing an easily recognizable object or the print of a photograph in front of and facing the subject (but outside the crop boundaries) so that it will be reflected off surface of the object.

▲ *Use of colored light and an interesting perspective can create impressive images of technical objects.*

*If the images are intended for use in a catalog, you should be careful to maintain a consistent perspective and lighting set-up.*

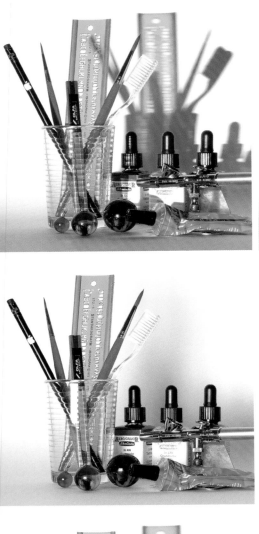

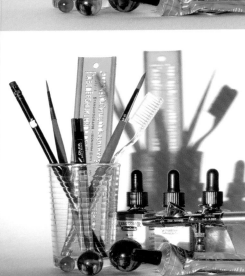

# Comparison in Lighting

Even with normal hot-shoe flash units, the light can be shaped and used creatively. Since the objects are very small, the sizes of the light sources are more moderate, which is an advantage with umbrella reflectors and softboxes. It becomes apparent that the larger the area of illumination, the softer the resulting light.

*Hot-shoe flash without accessories*

*Hot-shoe flash with diffusion screen*

*Hot-shoe flash with attachable softbox 26 x 16 cm*

*Hot-shoe flash with softbox 45 x45 cm\**

*Hot-shoe flash with softbox 60 x 80 cm with double diffuser\**

*Hot-shoe flash with barn doors\**

*Hot-shoe flash with honeycomb filter\**

*Hot-shoe flash bounced into a silver umbrella reflector, diameter 60cm*

*Hot-shoe flash bounced into a small reflector card\*\**

*\* mounted with adapter, adapter building instructions on page 128/129   \*\* building instructions on page 127*

# Imaging Techniques

If you are a beginner, you should play with a few standard lighting situations and closely observe the changing interplay of light and shadows, just for practice. This creates familiarity with the setup of lighting, and will allow for more time later to notice details while photographing. The techniques presented here are mostly oriented towards studio use, however, many can be converted for use with close-up photography in nature. Thus, you can use a stroboscope flash to photograph a launching bee in various flight positions; and a strong flashlight can be ideal to imitate the golden evening light of the setting sun, even when the sky is cloudy. For the example techniques that are presented here, I only used compact flash units and no studio strobe lighting, so it will be easy for beginners to recreate these images with little cost. Some of these, e.g., backlight, reproductions, translucent lighting, or a clean white background, can also be created with normal, incandescent lamps. Due to the strong heat build up, halogen lamps (especially spotlights) should not be used in the closeup range.

Little by little, as you gain more experience, you will develop your own techniques and style of expression. But, there are always new things to try, and that is what makes photography such an exciting and multi-faceted hobby.

▲ *Chives. Simple, graphic objects are perfect to study the play of light and shadow.*

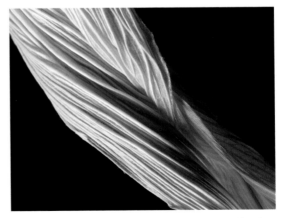

▲ *Corn Husk. The strong side lighting emphasizes the structure. Changing the lighting would result in a completely different picture.*

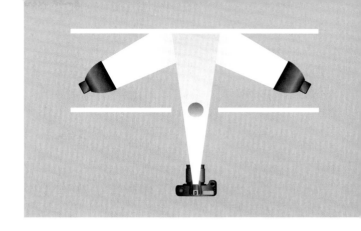

## Completely
## White Background

If an object needs a spotless, white background, it is necessary to lighten up the background to the point that it is, in effect, completely overexposed. Therefore, the background should be illuminated separately from the main object. Two flash units with small softboxes allow for an even illumination. With the illuminated background, you now have a classic backlit situation. The object must be separately lit from the front so it does not appear as a black silhouette. To avoid the bounce-back effect of light, set up white cardboards to either side of the object so that they are placed just outside the viewfinder range. If you are using the flash units without softboxes, you can also direct the flash to the back of these cardboard screens and thus attain a very even distribution of light across the entire background. If you place the object into the area between the background and the cardboard screens, it will also be side-lit from both flashes used to light the background. If you place the object further toward the front area, the background light has little influence on the object because the screens protect it from any reflected light.

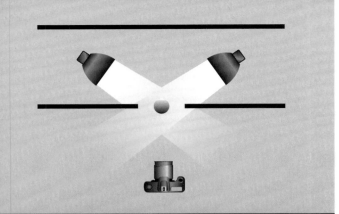

## Backlight and Black Background

The setup for a backlit scene is very similar to the one used for the white background, only the object is lit from the back. Choose the background material carefully, so that it reflects as little light as possible. Black velvet or black felt purchased from the photography store are ideal. If you use black cardboard for the background, you should increase the distance from the object to the background, since cardboards will reflect some light. Position the flash units in such a way that they light the object from a low angle. Two black cardboard screens (black on both sides) ensure that there is no reflected light on the object and that no light strays onto the background. Fine structures on the edge of the object may be overexposed, giving the object an interesting halo effect. If the front of the object seems too dark, you can lighten it by using a third flash with a lower output (for example, the internal camera flash).

## Setting Light Accents

The different color temperatures of flash and artificial light can be specifically used to simulate evening sunlight. Common flashlights are well suited for special lighting because their light can be focused onto a relatively small area. The requirements are a darkened room (to minimize the influence of surrounding light on the image) and a stable tripod for the camera. Set the camera to a small aperture and a shutter speed of several seconds. Take a few test shots to determine how much time is necessary to illuminate the scene according to your taste. In the example to the right, 2 seconds at f/22 was enough time to partially submerge the coffee beans in a warm golden light. For the actual photograph, set the off-camera flash to synchronize with the rear curtain. Now, shortly before the end of the exposure, the flash is triggered automatically and gives the basic lighting tone of the image. You can create variations by changing the output strength of the flash unit or by changing the shutter speed. Instead of synchronizing the flash with the rear curtain, another option is to manually fire the flash during the exposure.

# Reproductions

Even though it does not look difficult, reproductions have special requirements for lighting, setup, and lenses. Even a slightly angled camera can produce clearly visible distortions in the object. A stable reproduction holder is therefore almost mandatory. In addition, the lens should have very few distortions. Unfortunately, this is usually not the case with zoom lenses that are likely to show barrel-like distortions at most focal lengths. If you are using an SLR camera, it is therefore recommended to choose a fixed focal length lens, such as a 50mm macro lens or a normal lens. Digital compact or bridge cameras are not well suited for images that depend heavily upon exact reproduction. To achieve an even illumination without shadows, set up lamps or flash units from two sides (at equal distances to the object) at an angle of 45 degrees. To minimize unwanted reflections from an object that will not lie completely flat, you can hold it down with a glass plate. Choose a small aperture on the camera to work with a large depth of field and use a cable release or the camera's self-timer.

# Translucent Light

Many transparent items make good subjects to be photographed using backlighting. In this case it is colored marbles, but it could be orange slices, colored lollypops, gummy bears, or a host of other items. Placed on a pane of glass or a light table and lit from below, intense colors are reproduced well. It is necessary to also light the object from the top, so that the object will not appear too dark in those areas that are not translucent. Make sure that the lighting from below illuminates the area as evenly as possible. If you are using a light table, even illumination is not a problem. If however, you are using a flash unit from below, you should use a softbox or a diffuser and place the flash far away from the object, or bounce the light with a reflector. To avoid undesirable color-casts from different light sources, the same type of lighting should be used both below and above the object. When working with reflective surfaces you can determine the form and size of the reflections by carefully choosing your upper light source.

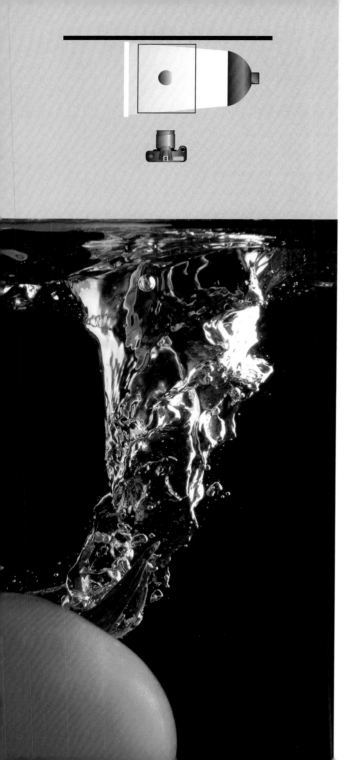

## Freezing Motion

Photographing objects falling into water can be very exciting, but this comes coupled with some work. After you have filled a small aquarium with water, attach the object to a thread (a thin nylon fishing line works well), and mark the dropping spot on the edge of the aquarium with a piece of tape. Now you can manually focus on the object and take a few test shots to determine the correct lighting. For the lighting, you can use an off-camera flash on one side, and a reflector on the other side to brighten the scene. Set the flash unit to a low output to achieve a relatively short flash recharge time. Manual hot-shoe flashes are particularly well suited for this task. They come in the lowest output mode at approximately 1/10,000 seconds, and some are even available at 1/20,000 seconds. Now, to capture your shot you only need to drop the object at the marked spot and trigger the camera simultaneously. A cable release is quite helpful here, and after a few practice attempts you will get a feeling for the right timing. Between shots you may need to remove the air bubbles that will cling to the side of the aquarium glass.

## Stroboscope Flash

The stroboscope flash not only allows you to freeze motion in photographs, but also captures the individual steps. To do this, many flash bursts are triggered in short durations, one after another. If the object moves during this time, it will be illuminated with each partial flash in a different position. Depending upon the shutter speed, pace of the object, and frequency of the flash bursts, the motion will be revealed, more or less, as a series of single frame exposures within a single image. The control "Hz" adjusts the frequency and determines the number of partial flashes fired per second. If you know the duration of the movement (or can make an educated guess) and the desired number of frames, you can determine the setting for the flash unit. Example: The duration of the movement is 2 seconds (therefore, 2 seconds is the minimum shutter speed), and you want 20 individual motion steps to be captured. You would use a frequency of 10 Hz (10 partial flashes per second x 2 second shutter speed = 20 images). It makes sense to work with the least amount of surrounding light for this effect. For the image on the right, I used a second flash from the back with a blue filter for a lighting effect.

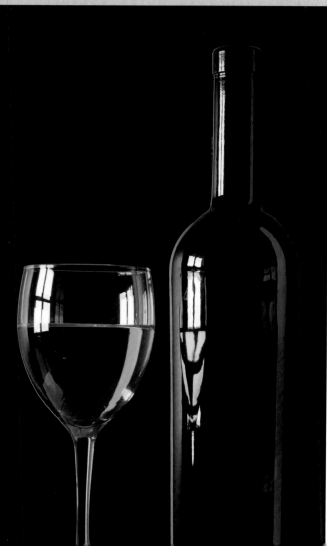

## Reflecting Windows

The term "lighting type" can be understood in two different ways. On one hand, it refers to the form of the light, and on the other hand, to the shape the light gives to the object. In this example, the wine glass and bottle are illuminated from the front with a 24 x 24 inch softbox which reflects off the shiny surfaces and thus gives the glass and bottle their characteristic form. The two black cardboard strips that were taped onto the diffuser created the illusion of a window to the left of the scene. With a few extra cardboard forms you could, for example, create the illusion of an arched window. The light reflection on the right side of the bottle was created with a small, white reflector that increased the three-dimensional effect.

*Two black cardboard strips on the diffuser create the illusion of window cross grids.*

## Multiple Exposures

Assuming that your camera supports multiple exposures, you now have a creative tool in your pocket to create many different effects. The simplest method is the soft focus effect that is created by combining a focused and a blurred exposure. The blurrier the second exposure is, the softer the effect. As seen in the example, another option is to move the point of focus from a near point in the first exposure to a point further away in the second exposure. This is how you can combine two different focal planes in a single picture. So that the overall image will not be too light, you will need to underexpose the individual exposures with a double exposure of approximately 1 stop. With 3 or even 4 exposures, you might have to underexpose up to 2 stops. Also, in the studio you can combine different exposures into one image, for example the outer shell and the inner core of a technical object. In all cases, you need a stable tripod and a cable or infrared release to ensure an exact alignment or registration of the individual exposures.

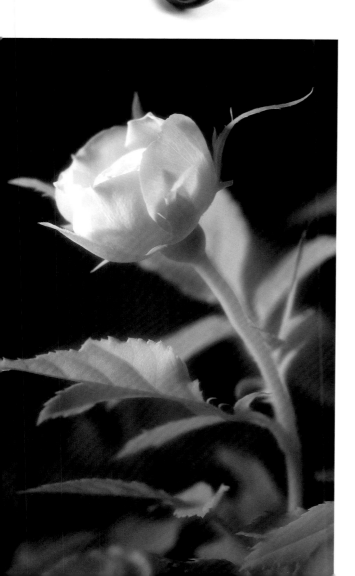

*Besides available sunlight, you can use an infrared light-bulb as a lightsource for your infrared shots.*

# Infrared
# Closeup Photography

Along with the increased popularity of digital cameras, infrared photography has become easier and more accessible. The infrared wavelength usable in photography is often described as near infrared range, which lies directly after the red portion of the visible light spectrum starting at 780 nanometers and is not visible to the human eye. All you need for infrared photography is a tripod and a filter that blocks the visible light. The best results will be achieved with an infrared filter #87, which removes all light below 740 nanometers. The lens should have a filter thread or a matching adapter tube. A basic requirement for infrared exposures is sunlight; the more sunlight the better. Since any minor movement of the object leads to motion blur in the closeup range, you can use a common infrared heat lamp and shoot your pictures in a windless studio. Objects from nature are especially suitable for infrared photography. Green leaves reflect most of the infrared light and thus appear almost white. The glowing effect of the Kodak HIE infrared film that is caused by the lack of antihalation coating can be achieved by making a double exposure, one sharp and one blurred.

## Ring Flash
## Used Creatively

The statement that ring flash units are not suited for shiny, metallic surfaces is generally correct because the flash tube reflects off the object, yet this effect has the potential to be used creatively. A few strips of colored foil attached with tape to the diffuser of the ring flash bathe the object in a shimmering play of colors that cannot be created with conventional lighting. Because the individual foils reduce the light intensity to various degrees, you get more play in the change of light and shadows. The lighting does not appear as flat. It is hard to control this effect because it is difficult to predict where the reflections fall, especially with curved surfaces. Therefore, the process of experimentation will be necessary, but this can be an enjoyable attraction of these images. Even with normal, rather documentary ring flash images, adding a bit of colored or gray filter foil on the diffuser can clearly improve the image.

◀ *Planter, detail, studio image. 1/90 sec at f/16; ISO 160; 50mm macro lens; a flash with softbox from the right. A white reflector on the left lightens up the shadows.*

▶ *Runuculus, studio image. 1/125 sec at f/11; ISO 200; 50mm macro lens; a flash with softbox lightens up the background. A second flash from the right is aimed at the flower. Both flash units are in manual mode.*

112

# Building Your Own Equipment

Because of the small size ratios in closeup photography, it makes sense to build some of your own "small helpers". This is because some accessories are quite expensive and some cannot be bought. Building your own equipment also has another advantage; if the situation requires a specific direction of light, your examination of the set-up and the available tools and technology are critical, giving you an excellent learning opportunity.

The equipment-building projects introduced here can easily be accomplished by amateurs. In addition to these projects, many common, everyday materials can be utilized. Clothespins can hold small things; the silver colored emergency blanket found in many first aid kits works as a wonderful reflector; and a translucent plastic bowl can serve as small light tent. Handmade backgrounds for closeup photography in the studio can add interest to images. Different colors painted onto a rough surface with a large brush or sponge are especially effective. Allow your creativity to roam freely.

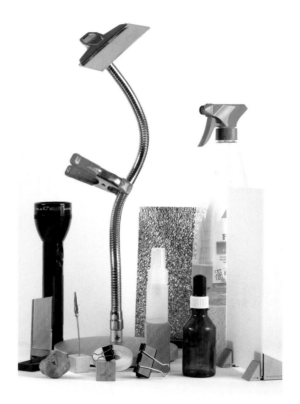

▲ *Somehow there is always something that needs to be held, clamped, glued, or cut. A large percentage of the many "small helpers" you will need are available at nearby office supply or home improvement stores.*

# Projection Spots

▲ *With a simple slide projector you can create interesting lighting effects.*

▲ *A small flash unit replaces the projector bulb and is triggered with a slave.*

Gobos are thin masks that are placed in the gate of a profile spot in order to shape the light beam, creating an endless variety of patterns that can add dramatic or subtle effects to any projection surface. They are used in the studio to create special effects, such as simulating light that enters through blinds. Unfortunately, the necessary projection attachments for the strobe flash units are very expensive. If you rarely use this effect, you can use an old slide projector instead. For this purpose, you must exchange the projector lamp with a small flash unit. If the rest of your light sources consist of daylight, you can use a simple 80B filter in front of the projector lens, which is enough to transform the yellowish halogen light to appear as daylight. Substitutes for the expensive gobos that normally consist of lighting patterns cast onto steel can easily be created in a graphics program on your home computer. You can then have them printed onto slides at a photo lab. The patterns should not be too detailed, as some details may be lost in the projection.

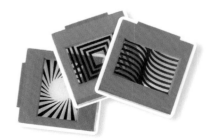

# Beanbag Tripod

If you want to take pictures close to the ground or you want to brace the camera (e.g., on a fence or other structure), a beanbag tripod steadies the camera very effectively, and protects the bottom of the camera and lens from damage. To make a beanbag of 8 x 6 inches, you need two leather pieces sized 9 x 7 inches, a strong 6 inch long zipper, and (depending on the thickness of the leather) a special leather needle for your sewing machine. First, fold in the edge of the short side to the inside (about 1/2 inch) and sew the zipper on the inside (rough side) of the leather. Turn the leather pieces inside out so that both smooth sides lie on top of each other, and sew the three remaining sides together with a seam allowance of 1/2 inch, so that the bag is created. After knotting the end of the threads, you can now turn the bag inside out and fill it with dry beans, lentils, or even styrofoam balls. Finally, you can treat the leather bag with a water repelling spray. Finished!

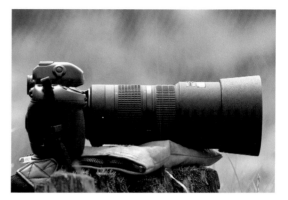

▲ *The beanbag eliminates movements and fits snuggly between the ground and the bottom of the camera.*

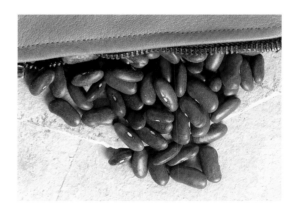

▲ *Fill the beanbag with common dry beans. If it needs to be especially lightweight, you can fill it with styrofoam balls.*

# Split-Level-Box

Everybody is familiar with spectacular photographs from the South Pacific that display the tropical underwater world and palm trees on the beach at the same time. Usually, an underwater camera or an appropriate housing is necessary. However, a small box made from glass combined with a right angle viewfinder allows you to take these images (termed "split-level" images) in closeup photography.

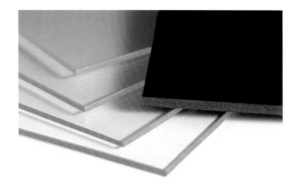

▲ *As basic materials, you can use glass plates, e.g., from old picture frames. The base plate is made from polystyrene.*

▲ *The glass plates and base plate will first be affixed with tape and then glued with silicon. To ensure that the box is water tight, you should not skimp on the application of the silicon.*

▲ *In the bathtub. 1/60 sec at f/11, ISO 160; 50mm macro lens; flash bounced off the wall of the tub.*

*Whether in a bathtub or in a tide pool by the ocean, split-level images always catch attention.*

For this, you need 4 small picture frames sized at 4 x 6 inches, a plastic base plate of 6 x 6 inches (for 1/8 inch think glass), silicon from a home improvement store, and a right angle viewfinder which you can purchase at a photography store or on the web. The assembly is quickly completed. First, affix the individual pieces together with transparent tape, and then glue them together with silicon. Use your fingers (dipped into dishwashing detergent) to spread the wet silicon. After the silicon has dried you can test it in the bathtub for leaks, and then glue the right-angle viewfinder into the box. Now you can use an adapter to combine the lens with the mount of the viewfinder. When choosing the lens for your particular shot, you should make sure that the front lens element does not rotate when focusing, or the box will also rotate when focusing. Also keep in mind that the focusing ring should not sit too deeply in the box or manual focusing will be quite difficult.

In addition to the split-level images discussed here, even underwater images are possible to a certain degree. You can always find interesting objects in the shallow tide pools by the sea or along the shallow edges of a lake. Because you have to use small apertures to reach a large enough depth of field, you should use a tripod or a flash. The attainable image quality is lower than with normal photographs, because the right-angle scope and the glass plate add two additional optical surfaces. But, the possibilities in creative imaging make up for this loss. It is important to remember that the box does not offer protection against water spray or an accidental dunking of the camera into the water. Therefore, you should be very careful while using this device, and also protect the camera with an underwater bag.

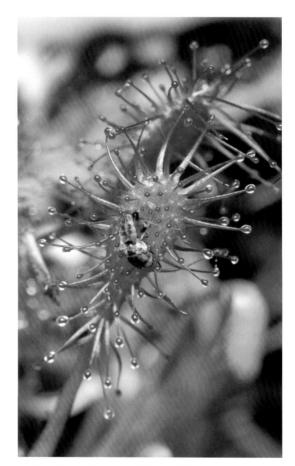

▲ *Sundew. 1/60 sec at f/9.5; ISO 200; 105mm macro lens; hot-shoe flash with softbox; right-angle scope. This perspective of the plant growing on the edge of a lake could only be reached from the lake side.*

*A right-angle scope is a great help, even without the split-level box, for taking pictures in awkward places.*

# Reflector Card

A reflector card for the hot-shoe flash can be quickly assembled. Simply score a rectangular piece of cardboard along the lines indicated in the diagram below (crease at the fold lines with the dull edge of a knife, so it can be folded more accurately) and attach onto the flash with a wide rubber band. Finished! The much larger area of illumination created from the reflector card renders a softer light and can be directed at the object by tilting the reflector. In addition to a white reflector card, you can also use silver, gold, or any other color for special effects.

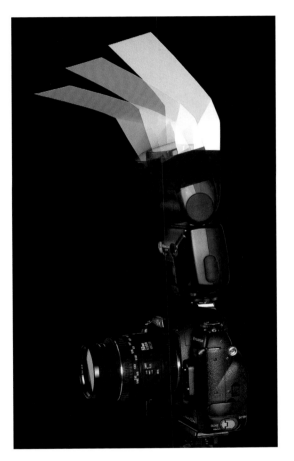

▲ *The cardboard reflector can be tilted with the flash head and allows for soft light from above (even with short focal length lenses and short distances to the object).*

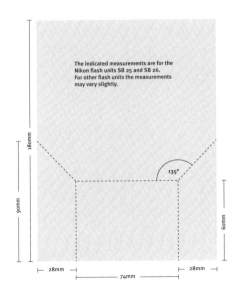

The indicated measurements are for the Nikon flash units SB 25 and SB 26. For other flash units the measurements may vary slightly.

135°

180mm

90mm

60mm

28mm   74mm   28mm

# Softbox Attached to Hot-Shoe Flash

At one time or another, most every photographer has wanted to adapt a softbox to fit onto the hot-shoe flash, or attach a honey-comb filter or barn doors by simply attaching the adapter to the tripod, and adding the flash and the softbox. Well, it is not quite that simple. First you have to build the adapter.

In terms of materials, you need one aluminum rail (or strips) measuring 30 mm x 3 mm x 295 mm, and a second aluminum rail for the holder measuring 30mm x 3 mm, with the length dependent upon the measurement of your flash. These aluminum rails can be purchased at a home improvement store. For tools, you will need a rubber hammer, drill, vice, riveter, and metal file. After cutting the rails to size, you need to drill the holes. Next, the 295 mm aluminum rail must be bent into a circular shape resulting in an outer diameter of 95mm. The ends need to remain flat so that the rivets (which later will combine ring and angle) will not exceed the diameter of 95mm. A uniform circle is best achieved if you bend the aluminum strip around a cylinder (e.g., a round post) and strike it with the rubber hammer. The measurements of the angle depend upon the flash (perhaps you might require the additional height of a slave adapter). Next, connect the ring to the holder using the rivets, and the hot-shoe can then be placed on the

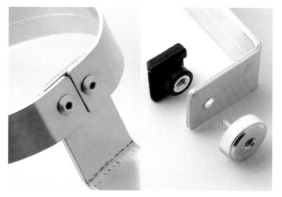

▲ *After making these parts, the ring and angle are connected with rivets. The hot-shoe and retaining screw can be bought at a specialty photography store.*

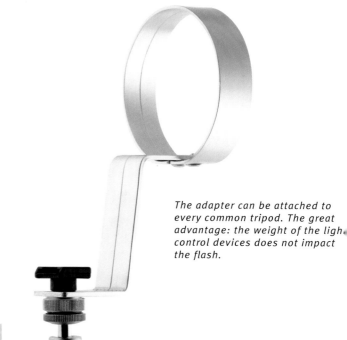

*The adapter can be attached to every common tripod. The great advantage: the weight of the light control devices does not impact the flash.*

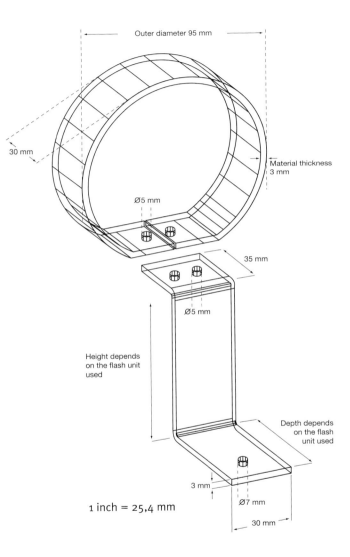

Outer diameter 95 mm

30 mm

Material thickness
3 mm

Ø5 mm

35 mm

Ø5 mm

Height depends
on the flash unit
used

Depth depends
on the flash
unit used

3 mm

Ø7 mm

30 mm

1 inch = 25,4 mm

tripod mount with the retaining screw. Both the tripod mount and the retaining screw can be bought in a photography store. To complete your project you can polish the adapter with steel wool to eliminate any work related marks. Now all softboxes, honeycomb filters, and barn doors with a 95mm adapter ring can easily be attached. Depending upon the flash unit and camera used, you now have a small, mobile flash unit independent from any electrical outlet. This will allow you to use TTL-flash, and perhaps even a wireless, rear curtain, or stroboscope flash, thus, you gain a range of function that goes far beyond that of a studio strobe system.

At home, you don't even have to do without the modeling light; you can just temporarily replace the flash with a clip light.

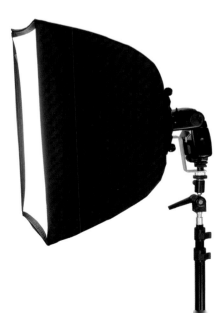